MURDERS & MISDEMEANOURS
IN
THE WEST END OF LONDON
1800-1850

Alan Brooke and David Brandon

AMBERLEY

First published 2009

Amberley Publishing Plc
Cirencester Road, Chalford,
Stroud, Gloucestershire, GL6 8PE

www.amberley-books.com

Copyright © Alan Brooke and David Brandon, 2009

The rights of Alan Brooke and David Brandon to be
identified as the Authors of this work has been asserted
in accordance with the Copyrights, Designs and Patents
Act 1988.

ISBN 978 1 84868 524 6

British Library Cataloguing in Publication Data.
A catalogue record for this book is available from the
British Library.

Typeset in 10pt on 12pt Sabon.
Typesetting and Origination by FONTHILL.
Printed in the UK.

Contents

Introduction

Crime in London 1800-1850

London has a long history of criminal activity. Before 1868, it also had an equally long history of brutal public punishments. These gruesome spectacles attracted huge crowds to the various sites of execution and torture where people would witness, or perhaps be entertained by, the grisly spectacle of the condemned going through the agonies of their proscribed ordeal.

The eighteenth century witnessed significant changes in criminal law, prisons and punishments. By 1800, the vast majority of those convicted of a felony were transported or incarcerated for periods from several weeks to years, often in hulks, floating prison ships moored in the Thames. These changes reflected concerns about social disorder and crime from the landed and mercantile elites, and by the men of property who helped to run the courts. The judicial system in Britain during the eighteenth and early nineteenth centuries was characterized by both cruelty and humanity but above all by flexibility mixed with pragmatism.

The transportation of convicts to Australia emerged as a means of maintaining domestic order rather than the requirements for imperial expansion. Australia was chosen in 1787 because Britain had lost its colonies in America and could no longer send its convicted criminals there. The notorious 'Bloody Code' had, throughout the eighteenth century, carried the death penalty for over 200 crimes. However, there was a growing concern, especially from those in positions of authority, that the public hanging of people was not having the desired effect of deterring people from committing crimes. The *Gentleman's Magazine*, in 1791, commented that 'instead of damping the feelings of the lower orders of people ... [public hangings] only served to heighten their wickedness.'

The thriving market in tabloid-style journalism expanded and was quick to recognise the insatiable appetite for sensation and titillation. It fed that appetite with descriptions of lurid crimes and the gruesome punishment of offenders. Until 1836, prisoners had no legal right of representation at their trial by a lawyer. Whippings, brandings, mutilations, transportation and public humiliation in the stocks and the pillory, all ended in the nineteenth century. In the first 36 years of that century, 523 people were hanged (including 22 women) at Newgate alone.

London's population grew at a phenomenal rate. In 1801, it stood at one million. By the end of the nineteenth century it had grown to over seven million. Migration had contributed greatly to this expansion and, from the 1830s, large numbers of Irish, Chinese

and Black people, as well as migrants from many parts of Europe, settled in various parts of London. Huge building developments, largely resulting from the railways, saw the clearance of many slum districts, particularly rookeries, such as St Giles, which had been nests of criminal activity.

The period covered here, 1800-1850, witnessed significant developments in the legal system including the introduction of the Metropolitan Police Force, the building of large prisons, a diminishing of the number of public executions, and the last public decapitation of condemned men. These years also include that decadent and indulgent phase known as the Regency period, which became as much associated with architecture and fashion as it did with rakes, rascals and extravagance. Many of these wealthy loafers frequented clubs and fashionable places around the West End.

The West End has long had a reputation for fashion, shopping, glamour, entertainment, and, in the case of areas such as Mayfair, of being an area full of the expensive houses of the wealthy. However, this image often belies another side, one with its fair share of murder, corruption, vice and intrigue in high places, as well as the most extreme poverty and degradation.

The crimes and criminals covered in this book represent a broad section of unlawful activity which varied from the pathetic petty thief, the desperate robber trying to survive for want of food and clothing, and those who might be classified as regular cheats, bullies, thugs and thieves. Crime in the West End spanned from the slums of St Giles to the mansions of Mayfair.

The book examines notable murders and misdemeanors between 1800 and 1850 in the West End. It draws on a wide range of sources, including newspaper reports, accounts from court proceedings and government records. The vast majority of crimes, for any period and place, consist of larceny and those committed in the West End during the period 1800-1850 are no exception. Searching through court proceedings, transportation records or newspaper accounts it becomes apparent that the overwhelming number of convictions are for theft of some sort — petty or great — burglary or picking pockets, shoplifting or violent robbery. There are a multitude of stories behind these 'misdemeanours': the sad, nasty, mundane, bizarre, incompetent and hilarious. The stories, of course, also involve unfortunate victims who were on the receiving end of such crime.

Policing

As London expanded in size and population during the eighteenth and nineteenth centuries the issue of maintaining law and order became a matter of public concern. The reliance upon part-time officials proved inadequate in dealing with law enforcement. Conditions in London became intolerable and begged for an effective and organised system of policing. Until 1829, arrests depended upon the victims apprehending a criminal and then contacting a police constable, hence the regular hue and cry of 'murder' or 'stop thief'.

What system of law enforcement there was depended upon constables expected to keep the peace, such as night watchmen, or 'watch', who patrolled the streets, and thief-takers, who received rewards for arresting and convicting criminals. Night watchmen originated in the reign of Charles II (1660-1685) hence their nickname, 'Charleys'. Many of them were ex-servicemen who were often disabled and not fit for other work. They were usually equipped with a stick for self-defence, a lantern and a rattle to raise alarm. Thief-takers were often knowledgeable about what was going on in the criminal fraternity and this, combined with the system of reward, often led to corruption.

The brothers Henry and John Fielding introduced a new type of thief-taker in 1748 who was hired on a retainer to follow up the reporting of a crime and then set about the task of attempting to arrest the culprit. This force became known as the Bow Street Runners and established a formidable reputation. By the early nineteenth century, horse and foot patrols and river police to patrol the Thames were in operation.

In the years 1812, 1818 and 1822, Parliamentary Committees were appointed to investigate the subject of crime and policing. But it was not until 1828 when Sir Robert Peel set up his committee that the findings paved the way for his Police Bill, which led to the setting up of the Metropolitan Police in 1829. This created a force of 3,000 men under the control of the Home Secretary. They had responsibility for policing the entire metropolitan area, except the City of London. They were armed with wooden batons and called 'Bobbies' or 'Peelers'. By 1839, a second Metropolitan Police Act extended the force's jurisdiction from ten to fifteen miles from Charing Cross, increased the number of men to 4,300 and created a similar police force for the square mile of the City of London. Three years later a detective force was set up within the Metropolitan Police Force.

In 1819, a strange anomalous force appeared in the West End; it had its own set of rules and regulations and enforced its own police force. It was the smallest in the world and still exists

today. Burlington Arcade, which runs behind Bond Street from Piccadilly, was Britain's very first shopping arcade and opened to great acclaim. The longest covered shopping street in England, and possibly the most elegant, was built by the order of Lord George Cavendish. The Burlington Beadles were originally recruited from Cavendish's family regiment, the Tenth Hussars, and patrolled the arcade resplendent in their top hats and tails. Today, they are still smartly attired, but are more likely to be giving directions to tourists. They still make sure the old rules are adhered to, which include not running, singing, humming, playing an instrument, carrying large parcels, riding or pushing a bicycle or walking with an unfurled umbrella in the arcade.

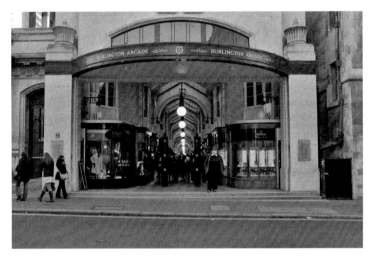

The Burlington Arcade, established in 1810, as it appears now.

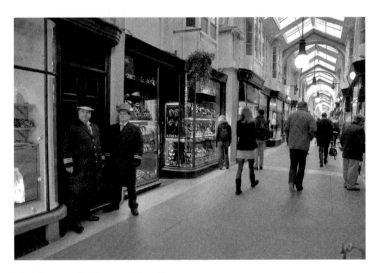

The famous Burlington Beadles.

The West End

The West End of London has often had a shifting geographical definition. The West End consists of four particular areas: the north-west consists of south-Marylebone; the north-east, Fitzrovia; the south-east, Soho; and the south-west, Mayfair. These form the area of W1, although there are parts that are technically W2 but would be considered by many as the West End such as Charing Cross Road and Leicester Square. The West End includes such diverse places as the wealthy Mayfair, the bohemian Soho, and the old parish and rookery of St Giles, which was incorporated into Holborn in 1900. Mention the West End and many people think of famous names such as Regent Street, Oxford Street, Soho and Piccadilly Circus. These areas are well-known tourist spots with their shops and sources of entertainment. However, as with so much of London, this image belies another rich, fascinating and, on occasion, dark history.

MARYLEBONE

Marylebone, an area once covered by forest and marshland as part of the great forest of Middlesex, evolved from two adjacent manors; the Manor of Lillestone and the Manor of Tyburn. In 1400, the new church was dedicated to St Mary the Virgin (by the bourne) and it was shortly after this that Marylebone replaced the name Tyburn. By the 1720s, the growth of Marylebone allowed the *Daily Journal* to comment that people were arriving in London from their country houses in Marylebone. This development in the eighteenth century was associated with notable landowners, the Portmans and Portlands, who began to develop fashionable houses and squares to the north of Oxford Street that shaped the identity of Marylebone, such as Cavendish, Portman, Manchester and Montagu Squares. In addition, many famous streets were established, including Baker Street, Harley Street, Wimpole Street, Wigmore Street and Marylebone High Street. Many people will the know the area by some of its well-known landmarks, such as Madame Tussauds, Regent's Park, Broadcasting House, the Wallace Collection and, further to the north, London Zoo. Marylebone is a sizeable, diverse and complex area consisting of parts of London W1, NW1 and NW8. It is the W1 part that concerns the purposes of this book. This area is contained at its western part by Edgware Road, north to Marylebone Road, east to Portland Place, south to Oxford Street then west back to Edgware Road. Despite its fine

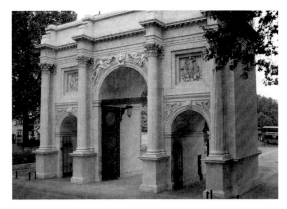

Marble Arch, which was moved to its present site in 1851 near to the where the infamous Tyburn gallows were located.

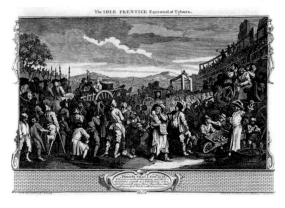

William Hogarth's portrayal of the infamous Tyburn gallows in the eighteenth century. The last execution at Tyburn was in 1783.

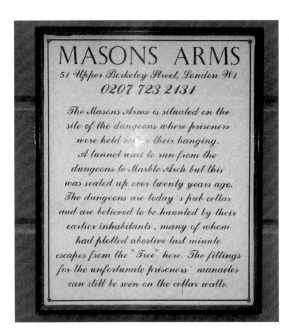

The Masons Arms is reputed to have cells that held prisoners.

Georgian houses it was also notorious for its contribution to the dark history of London, which included high-class prostitutes, usually referred to as courtesans; the number of murders and infanticide cases; the infamous Tyburn gallows; and the Cato Street Conspiracy of 1820.

OXFORD STREET

Oxford Street divides Marylebone and Fitzrovia on the north with Mayfair and Soho to the south. To the thousands of people who walk, shop or commute along the one and a half mile stretch of Oxford Street today there is little evidence of its pre-Victorian history. Oxford Street's reputation as one of the world's most famous, busiest and longest shopping streets has its origins in the late eighteenth century. It was also in the earlier eighteenth century that this old Roman road acquired the name Oxford Street. The road, which was administered by a turnpike trust from 1721, was described as, 'a deep hollow road, full of sloughs; with here and there a ragged house, the living place of cut-throats.'

Despite the early rural nature of the area a regular flow of traffic used the road for centuries. Oxford Street, previously known as Uxbridge Road and Tyburn Road, formed part of a Roman road that went from Hampshire to Colchester in Essex. It was also a major route between the City and the west for travellers, as well as livestock, brought to market from the west.

The Tyburn gallows, situated at the west end at the junction with Edgware Road, could always guarantee huge crowds, who made the journey from the City and outlying areas. With the removal of the Tyburn gallows and the developments around Park Lane, including the demise of the May Fair, which was held every year from 1 May for fifteen days, the stigma associated with the area was removed. As well as the regular traffic, which used the route of Oxford Street, the crowds attending the executions also added to the bustle of this rural setting. The road also became the haunt of highwaymen and thieves thus establishing the area with a notorious reputation for violence.

The Tyburn River is now completely enclosed and flows through underground conduits for its entire length. Part of the course of the river is marked out by the meanderings of Marylebone Lane and by such names as Brook Street and Conduit Street. A small depression in Oxford Street close to Stratford Place still bears evidence of the hidden presence of the river.

From 1718, piecemeal development along Oxford Street started at the Tottenham Court Road end. In the twenty years after 1763, the expansion astonished foreign visitors. It was entering an age of refinement defined by the fashionable houses to the north and south-western end, as well as the shops, coffee houses, public houses, 'lacquered coaches ... pavement inlaid with flag-stones' and the 'splendidly-lit shop fronts'. By the later eighteenth century Oxford Street and its immediate area was well placed to take advantage of London's westward expansion. With its Georgian architectural elegance and

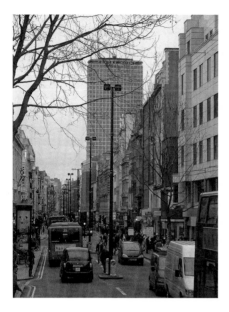

A view of Oxford Street today — looking towards Centre Point.

the proliferation of shops, this famous street attracted consumers and visitors in large numbers. It was also a magnet for street entertainers and a multitude of pickpockets, shoplifters and thieves, drawn to the rich pickings of shops and shoppers.

FITZROVIA

The north-east end of Marylebone was once part of the adjoining Manor of Tottenhall (Tottenham) at one time owned by Charles Fitzroy, Duke of Southampton. Fitzrovia has developed a feeling akin to that of many of London's 'villages'. John Roque's map of 1746 reveals very few buildings in this area although considerable development of high-class residential property had already taken place a short distance to the west.

Property development in Fitzrovia began in the 1700s. The area and the name were associated with Fitzroy who bought the fifteenth-century Tottenhall Manor and its freeholds in the 1700s and employed the Adam brothers to develop the east and south sides of Fitzroy Square. Buildings in the area were rapidly sold to a variety of service industries, and much of the residential property had insecure tenancy agreements. Not surprisingly, the area attracted a mixture of struggling artists and self-employed tradesmen, as well as rapidly growing immigrant groups. The area has always attracted immigrants, some of them refugees from political persecution. They ranted and raved with and at each other in the district's innumerable pubs, coffee houses and other meeting places. They either got on with or, sometimes, found themselves in violent disagreements with the indigenous radicals and other activists who made their homes around Fitzrovia.

It was this mixture of people that gave Fitzrovia its distinctive bohemian character. Fitzrovia lies partly within the London Borough of Camden and partly in the City of Westminster.

MAYFAIR

To the west, Mayfair, which takes it name from the May Day Fair, developed from the seventeenth century. Until then it was a mixture of cottages, with pockets of poverty in the back streets. The May Fair was closed down in the late eighteenth century when residents complained that it was lowering the tone of the neighbourhood. A network of roads and houses were built east of Park Lane, then Tyburn Lane, between the mid-seventeenth century and the mid-eighteenth century, making it into a fashionable residential district.

A number of wealthy landlords were instrumental in this expansion. The most important was the Grosvenor family. Grosvenor Square emerged on what was the large Grosvenor estate, which had resulted from the marriage, in 1677, between Sir Thomas Grosvenor, a Chesire landowner, and Mary Davies, heiress to 100 acres of land in Mayfair. Grosvenor Square was completed by 1737. By the nineteenth century, Mayfair had become one of the most fashionable places in London to live and housed many of the great aristocratic families (as well as Anglican bishops) in magnificent mansion houses. Further east a combination of houses and shops sprang up on Bond Street — a street Dickens described as 'a well to do area of London'. Mayfair's neighbour, St James, attracted eminent politicians and aristocratic young men and dandies, such as Beau Brummell, to the gentlemen's clubs where they indulged in the craze for gambling. However, the craze came to an end by the 1840s with the introduction of anti-gambling legislation. A number of well-known courtesans, who were kept and feted by wealthy and titled men, had their residences in Mayfair.

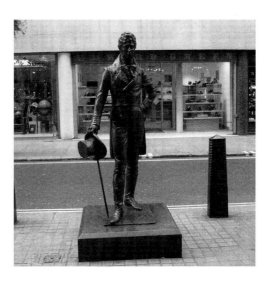

Statue of Regency dandy Beau Brummel on Jermyn Street, erected in 2002.

SOHO

Soho, prior to the seventeenth century, was mainly farming and game land attached to Westminster Palace and used by the affluent inhabitants of London. The name Soho, which derives from an old hunting call used to call in the hounds, reflects this association. The crown acquired the area in the 1530s and until the Restoration in the 1660s it was little more than fields with a few cottages in the Wardour Street area. Later, in the seventeenth century, Soho began to be developed, largely by Gregory King, to alleviate the over-crowding in the centre of London.

It was during this period that many refugees from Europe, including Greek Christians fleeing Ottoman persecution, moved into the area. There were also Huguenots (French Protestants), who escaped from France during the repression of Louis XIV's reign, and many other immigrants, including Italians, Russians, Poles and Germans. Many of these were craftsmen, such as clockmakers, bookbinders, tailors, painters, furniture makers, and silversmiths, who set up businesses in the area. Landowners, such as the Earls of Leicester and Portland, never developed the area on the scale of neighbouring Marylebone and Mayfair, and, as such, it did not become a fashionable area for the rich.

Soho established a reputation from this period as a cosmopolitan part of London, and in the eighteenth century aristocrats who had been living in Soho Square and Gerrard Street moved away. By the nineteenth century, music halls, small theatres and prostitutes had moved into Soho. The latter contributed to the twentieth-century image of the area as being at the heart of London's sex industry. *Time* magazine in 1975 (16 September) commented on the tradition of prostitutes in the West End with a rather jocular view of their impact on tourists:

> Public prostitution flourishes more conspicuously in London than it does in any other major capital in the world … From noon until the small hours of the morning, London's vast troop of trollops are busy as squirrels in the fashionable West End … They throng four deep on the sidewalks under the bright lights of Piccadilly Circus, [patrolling] Mayfair, Park Lane and Bond Street.

ST GILES

At the eastern end of Oxford Street, stretching between Charing Cross Road and Lincoln's Inn Fields, was the notorious district of St Giles. This was 'The Rookery' where a large, impoverished Irish population lived. The area, with its network of alleys and yards, was rife with poverty, filth, crime and overcrowding. It proved to be of great concern to social commentators, and the Reports of Select Committees described it as such:

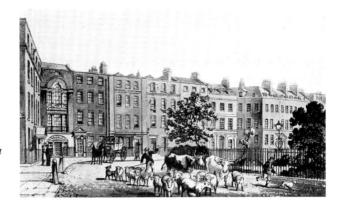

Soho Square in 1816 from an aquatint in J. B. Papworth's Select Views of London (1816).

Soho Square today.

St Giles-in-the Fields' church, built by Henry Flitcroft, was completed in 1763.

In St Giles one feels asphyxiated by the stench: there is no air to breathe nor daylight to find one's way out. Frederick Engels wrote in 1844: Heaps of garbage and ashes lie in all directions, and the foul liquids emptied before the doors gather in stinking pools. Here live the poorest of the poor, the worst paid workers with thieves and the victims of prostitution indiscriminately huddled together.

Similarly, Dickens described a visit to a lodging house in St Giles where the poor, mostly Irish emigrants, are 'heaped upon the floor like maggots in cheese' (*Household Words*, June 1851). Little wonder then that St Giles became subject to a huge clearance during the 1840s, giving way to New Oxford Street in 1847. However, development of the area was hindered by financial restraints and criticisms were still being made by the 1870s. Commenting on Church Lane as late as 1874 a *Report of the Commissioner of the Police of the Metropolis* stated that, 'Its condition is a disgrace to the great city'. However, New Oxford Street did improve communications and connected Oxford Street direct to Holborn.

By the end of the century, many of the prostitutes were gravitating to the West End. In addition, there was an abundance of coffee houses, brothels, taverns and bagnios (bath houses that were really brothels).

HAYMARKET AREA

Recorded in Elizabethan times, the Haymarket was, as the name suggests, predominantly used for the sale of farm produce. By the nineteenth century, Haymarket, Windmill Street and Leicester Square saw large numbers of women patrolling the area in the arcades, shopping streets, theatre entrances, alley corners, taverns and courts. The area also had an abundance of 'accommodation houses' where rooms could be let for 'business'. Kellow Chesney, in his book *The Victorian Underworld* (1970), commented that:

Along the line of the Strand and as far as the neighbourhood of the Haymarket itself, were coffee houses, cigar divans, chop houses and other masculine resorts well known to have unadvertised bedrooms at their customers disposal. Prostitutes would drop into some of these, especially perhaps the cigar shops, to pass the time of day and cast an eye round for clients.

In addition, places such as Caudwell's dance hall in Dean Street and the Café Royal in Princes Street, Leicester Square, presided over by the huge Mrs Kate Hamilton, were among the most well-known venues for entertainment which depended on prostitution.

The number of prostitutes around the Haymarket prompted a correspondent to write to *The Times* (21 October 1846) appealing to policemen to go to there (presumably

The Haymarket today is a very different street to that in the first half of the nineteenth century.

not dressed as policemen) in the evening where they would be 'received with terms of endearment, and embraced with an ardour dangerous to your pockets'. Should any man resist the temptations, the writer added, 'be assured you will have abundance of abuse'. Interestingly, the correspondent had sympathy with the women who he felt were often 'more sinned against than sinning, they are driven to a course of life most hateful to themselves, till, feeling that they are for ever banished from respectable society, and are unnecessarily persecuted, they become perfectly indifferent to the opinions of the world, and careless as to every thing but their own immediate wants.'

A measure of how populous the area was with such trade the writer pleaded, 'that the higher police authorities will give attention to the state of the Haymarket, which is worse than any other in London, and that they will secure us a free passage through it.'

CHARING CROSS, TRAFALGAR SQUARE AND PICCADILLY

The Strand connects Westminster with the City, but the part that concerns this book is the area of Charing Cross. In 1830, this end of the street saw improvements, which led Disraeli to describe it as 'perhaps the finest street in Europe'. This was a far cry from the area that had witnessed the brutal executions of eight regicides in 1660. The stench emanating from the burning of their intestines brought complaints from the residents around Charing Cross and so the remaining regicides were executed at Tyburn. Trafalgar Square was not named as such until 1835 when it was laid out on the site of what had been the King's Mews, a menagerie and a store for public records.

Piccadilly is one of the ancient roads leading from Piccadilly Circus west to Hyde Park. The name derives from 'picadils', stiff collars which were fashionable at court and were produced by a tailor, Robert Baker, who made such a fortune from this trade he bought land north of Piccadilly Circus and had a fine country house built, Piccadilly Hall. Piccadilly Circus was formed out of the intersection with John Nash's Regent Street in 1819. As with many places that had shops or business premises, Piccadilly was subject to a great deal of theft; much of it was mundane and petty but the punishment for such crimes could still be very harsh.

Trafalgar Square, a famous West End landmark laid out in the mid-1830s.

Sources

London is particularly well provided for, with libraries and archives that contain a wealth of historical sources. These include the Guildhall Library, which is a major public reference library specialising in the history of London, especially the City. In addition, there is also the City of Westminster Archives, the National Archives at Kew and the British Library Newspaper Library at Colindale in north-west London. There are many good Internet sites, especially www.oldbaileyonline.org, which contains over 100,000 records of the Old Bailey Proceedings between 1674 and 1913 (see also 'Old Bailey and the Central Criminal Court: Criminal Trials' in the National Archives). A good site for locating information on the nineteenth century is http://victorianresearch.org/.

The National Archives holds criminal registers, which list all people indicted for criminal offences as well as the verdicts. Middlesex (including the City of London) is covered by the Home Office series (HO 26) from 1791 to 1849. There are many more documents, including the list of prisoners held for trial at Newgate, 1782-1853 (HO 77/1-61). The National Archives also holds many records relating to convicts who were transported to Australia, and this is a good source to follow up criminals who received such a punishment. In trials at the Old Bailey many criminals were sentenced to death but these sentences, other than those for murder, were commonly commuted to transportation. Details of convicted criminals can be found in the National Archives records (HO 17 for the period 1819-39 and HO 18 for 1839-54). For convicts transported after 1850 to Western Australia the Fremantle Prison website http://www.fremantleprison.com.au/index.cfm holds an extensive database containing many personal details of convicts.

The nineteenth century saw a spectacular increase of periodical literature. These varied from the moralizing to the political, the seditious to the scandalous. These publications benefited from the technological changes in an industrialized Britain, which made publications cheaper and more available, and London had more than its share of such periodicals and newspapers. Publications such as *The Police Gazette*, a weekly newspaper which gave details of crimes committed, is of particular interest for anyone wishing to explore the criminal underworld of Victorian England.

The Regency Period and the Real Tom and Jerry

Contemporary insights into early-nineteenth-century London life are offered through a range of newspapers, journals and publications. The period 1811-1820 is often referred to as the Regency period, when King George III, because of his illness, was deemed unfit to rule and his profligate son was installed as Prince Regent. The term Regency has been expanded to cover a period from the late eighteenth century to the 1830s in order to characterise particular fashions, politics and culture. Another association is with aristocratic excess, when well-to-do dandies flaunted their fashions, indulgent tastes and, sometimes, their bad behaviour. This period saw an increase in organized crime as entrepreneurs recruited gangs of robbers and ran brothels. Ill trained and ineffective watchmen and police were unable to establish order.

A Regency writer who reflected on this particular life style was Pierce Egan (1772-1849). Corinthian Tom and Jerry Hawthorne were his creations and, like their latter day cartoon namesakes, the pair was often associated with fighting, causing trouble and getting into various scrapes. Their activities spanned across a great deal of London, particularly the West End.

Egan was a very early sportswriter, journalist and writer on popular culture, especially boxing, and he produced a serial publication, *Boxiana, or Sketches of Ancient and Modern Pugilism* (1813-1828). It was his monthly journal, *Life in London, or The Day and Night Scenes of Jerry Hawthorn Esq. and his Elegant Friend Corinthian Tom*, which he began in 1821, that became his most well-known and popular work. Egan's tales tell of the rough and tumble of street life through the adventures of rich young Regency men. They ride in the parks, box and fence, visit the opera, take part in heavy drinking and rioting, bet on cock fights and the dogs, gamble, go slumming, keep mistresses, indulge in many forms of debauchery and visit brothels. Insights into brothels are revealed in Egan's observations when he notes that, 'in the Metropolis ... prostitution is so profitable a business, and conducted so openly, that hundreds of persons keep houses of ill-fame, for the reception of girls not more than twelve or thirteen years of age, without a blush upon their cheeks'.

The fictitious Tom, the 'man about town', and the archetype of the well-to-do idler of his time, was portrayed as the hero in the stories. He stands in contrast to his country cousin, Jerry Hawthorn, the cheery fool to whom he shows the pleasures of the town. This 'flashy' pair are involved in many misdemeanors but get away with more than they deserve because of their occupations and amusements, which typified those of many high-bred English gentlemen.

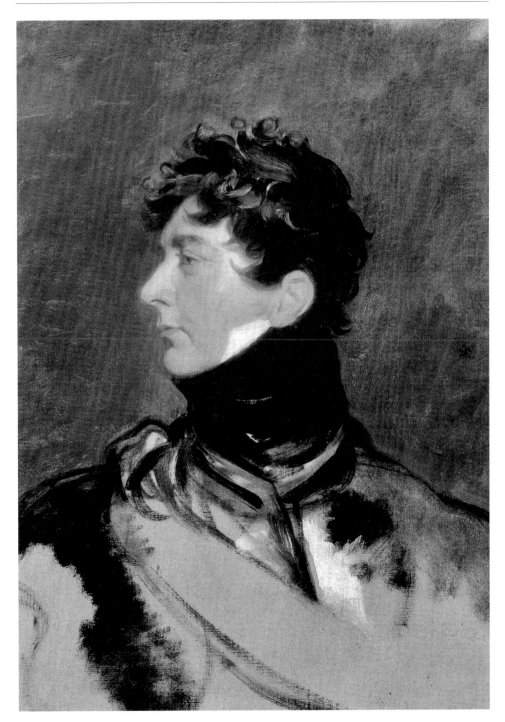

King George IV (1820-1830). As Prince Regent between 1811 and 1820 he exemplified the extravagance of the Regency period.

CHAPTER 1
Attempted Murder

High profile figures, such as monarchs, political leaders and even celebrities, have been targets for assassins. Between 1800 and 1840, there were a number of daring attempts, but the three cases that appear below are particularly interesting, for in each instance the culprit was deemed to be insane.

KING GEORGE III

The Theatre Royal, Drury Lane, has an eventful history. Built four times on the same site, the first building (1663-1672) was destroyed by fire in 1672. The second building (1674-1791) was re-built by Sir Christopher Wren and demolished in 1791 because it was too small. The third building (1794-1809) burned down for the second time in 1809, whilst the fourth and present building was built in 1812. It has been associated with some of the greatest actors in history as well some famous attempted murders, and it also boasts a few resident ghosts.

In the fortieth year of his reign King George III (1738-1820) had suffered not only from bouts of 'madness' but also from the antics of his oafish son George, Prince of Wales, the future King George IV. Between 1793 and 1815, Britain was at war with France and experiencing increased taxation and bad harvests. George's extravagance did not help and in fact contributed to his unpopularity. Not surprisingly, several attempts were made to assassinate him. The nearest attempt came in May 1800 when James Hadfield tried to shoot him at the Theatre Royal.

James Hadfield (1771-1841) served in the British forces and was captured by the French but not before he had been struck by a sabre on the head eight times, which left him with prominent wounds for the rest of his life. He later became a fervent believer in the second coming of Christ and this was a crucial factor in his assassination attempt on George. Hadfield believed that the second coming would be advanced if the British government took his (Hadfield's) life. How could he ensure this would happen? The answer was to kill the king and then bring about his own execution for treason.

On the evening of 15 May, during the playing of the national anthem, Hadfield fired a pistol at the king who was standing in the royal box. One witness, a musician, saw Hadfield with a pistol in his hand, pointing it at the king. The pistol was instantly fired

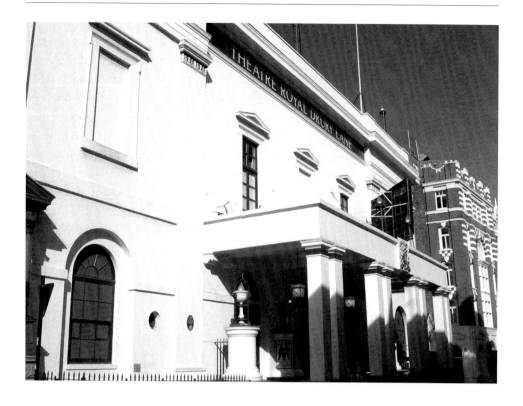

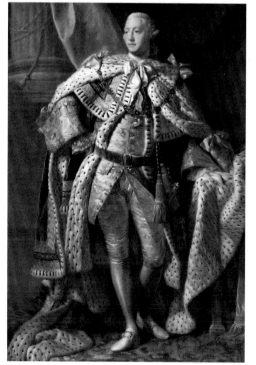

Above: *Theatre Royal, Drury Lane.*

Left: *King George III, who survived the assassination attempt on him.*

and dropped. A number of musicians then grabbed Hadfield and dragged him over the rails, into the music-room. Hadfield was heard to cry out, 'God bless your Royal Highness, I like you very well; you are a good fellow. This is not the worst that is brewing.'

Hadfield's shot had missed his intended target by fourteen inches. Although the bullets only just missed it was said that the king continued to watch the play and was so unconcerned by these events that he fell asleep during the interval. At his trial Hadfield pleaded insanity, an issue that the leading barrister, Thomas Erskine supported. Two military surgeons and a physician gave evidence in favour of Hadfield's unsound state of mind. However, his acquittal caused a public outcry and prompted Parliament to pass the Criminal Lunatics Act, which provided for the indefinite detention of insane defendants. Hadfield was detained at Bethlam Royal Hospital for the rest of his life, where he eventually died of tuberculosis. The second coming of Christ had not been hastened and would have to wait.

CELEBRITY OBSESSION

Celebrities have attracted attention from fans which has at times have bordered on obsession. Frances Maria Kelly (1790-1882) was a particular example of this type of attention. She was the first woman to devise and perform a one-woman show, and when she retired from the stage in the 1830s she founded a drama school for women in Dean Street, Soho. During her esteemed career as a singer and actor, she developed close acquaintances with Charles Dickens, the Duke of Devonshire and the Earl of Essex. She also maintained a close friendship with writer Charles Lamb (1775-1834) who proposed marriage to her in 1819. Sadly, she lived out her later years in relative poverty and died just before receiving a monetary prize associated with the Literary Fund award, which was conferred on her by Queen Victoria.

Her popularity on stage brought her many admirers. One of these was George Barnett who had already declared his attachment towards her in at least two letters. His obsession with Frances became the cause of a serious incident on the 17 February 1816 when Miss Kelly was performing at the Drury Lane Theatre in the farce, *The Merry Mourners*. In one particular scene, Miss Kelly and a male actor, Mr Knight, embraced each other. After they parted, Frances was retreating backwards towards the stage door when Barnett, who was in the audience, stood up holding a pistol in his right hand and pointing towards the spot where Miss Kelly was standing. Terrified witnesses then saw a flash and heard the sound of a gun. Commotion broke out as people tried to seize him. Barnett insisted, 'I am not the man who fired it; don't take me'. The evidence was rather stacked against him, with so many witnesses to the shooting and the fact that a small tin-full of gunpowder was found in his pocket. Fortunately for Frances Kelly, his aim had been as good as his protests of innocence. Shot marks were found on the lamps of the stage door, near to where Miss Kelly had been standing and also in the orchestra. The pistol was the same type that had been used by John Bellingham four years earlier to kill the British Prime Minister, Spencer Perceval.

Theatre Royal in Drury Lane, sketched when it was new in 1813.

In court Barnett said that he shot the gun as an alarm, but when asked the obvious question as to why he pointed it towards Miss Kelly his strange response was 'she knows'. When Frances Kelly gave evidence she stated that she had not the least acquaintance with Barnett but acknowledged the letters he had sent and added that she had never responded to them. Barnett later admitted that he had intended to kill Frances Kelly.

The letters actually worked in Barnett's favour as it was established that he had suffered from bouts of depression and strange behaviour throughout much of his life. When the letters were read in court it was argued that they provided evident symptoms of a deranged mind. Barnett was found not guilty on the grounds of insanity, but he was detained in custody. Four months after this attempt on Frances Kelly's life another person attempted to shoot her, this time in Dublin, and in doing so injured a bystander. What had Frances done to attract this kind of attention?

HIGH TREASON: THE ATTEMPTED MURDER OF QUEEN VICTORIA

Attempts to assassinate prominent people are as old as history. Some have been successful many have not. The only high profile assassination in British history was that of Spencer Perceval (1762-1812) in May 1812 when John Bellingham shot him in the heart in the lobby of the House of Commons. When Edward Oxford tried to kill Queen Victoria in

June 1840 one might have thought that hanging, drawing and quartering would have been reintroduced for such an act of high treason. However, times had changed and Oxford never even got near to a scaffold.

Oxford was an eighteen-year-old labourer who originated from Birmingham but had lived most of his life in Lambeth. A month before the attempted assassination he bought a powder flask and a pair of pistols for the sum of £2. He also took some target practice in shooting galleries in Leicester Square and the Strand.

It was the custom of Queen Victoria to take an airing in the afternoon or evening in the parks without any military escort. Oxford was aware of this and on Wednesday 10 June, about four o'clock, he went into Green Park. He stayed for a while then made his way to Constitution Hill, and waited there for the Queen. About six o'clock, the Queen, accompanied by Prince Albert, left the palace in a low open carriage, drawn by four horses, with two outriders, but no other attendants.

The carriage was driven up Constitution Hill where Edward Oxford watched their progress. When the carriage came into view he drew a pistol and then started shooting in the direction of the Queen. The pistol ball was heard to whiz by on the opposite side of the carriage and, in all probability, the Queen was unaware that an attempt had been made upon her life. Undeterred by his miss, Oxford drew out another pistol from his coat and aimed at Victoria. On this occasion she saw him fire, because she stooped down.

The Queen's carriage immediately drove on. As might be expected, when members of the royal family went on such regular outings people turned out in the hope of seeing them. One man who had witnessed what had happened rushed across, seized Oxford and took the pistols from him. This was followed by some confusion. The man shouted 'you confounded rascal, how dare you shoot at our Queen?' Oxford responded by accusing the man of doing the shooting.

Once this fracas was resolved Oxford was taken into custody. When his house was searched the evidence was pretty damning. The police found a sword and scabbard, two pistol-bags, a powder-flask, three ounces of powder, a bullet-mould, five leaden bullets and some percussion caps.

The court was crowded to excess on the two days of the trial. The charge was read, and it pronounced Edward Oxford as a traitor to the Queen. It was stated that he 'maliciously and traitorously, with force and arms … intend to bring and put our said lady the Queen to death.'

Oxford pleaded not guilty and his defence presented a vast body of evidence in support of insanity. Part of this evidence attempted to show that Oxford had been subjected to physical abuse as a child. His mother appeared as a witness to testify to the brutal injuries her husband had inflicted on her and her son. She added that Edward, throughout his life, had exhibited symptoms of imbecility, in which he would frequently burst into tears or into fits of laughter without any cause, and also exhibited a 'most anxious desire to obtain

celebrity in the world'. He had apparently pointed pistols at the head of his sister or his mother on frequent occasions. Medical witnesses were emphatic that Oxford was of an unsound state of mind and supported the case for insanity.

On the second day of the trial the jury returned a verdict acquitting Oxford on grounds of insanity. He was ordered to be detained during her Majesty's pleasure, and was subsequently conveyed to Bethlem Royal Hospital, better known as Bedlam asylum. The pistol with which he shot at the Queen is in the Criminal Museum at Scotland Yard, Victoria Embankment.

A Dangerous Liaison

Sarah Wood paid a heavy price for refusing to go home with John Taylor on the evening of 12 May 1808. She had met Taylor, an ex-sailor, at the corner of Marylebone Lane and then went for a drink at the Angel. Shortly after they walked towards Portman Square, where Taylor asked her if she would go home to his lodgings with him. When she refused he pulled out a knife and struck it forcefully into the left side of her stomach and her hand as she tried to stop him. Although in great pain, Sarah summoned up enough energy to run away. As she did she met a coachman who escorted her to the watchhouse in Manchester Square before she was taken to Middlesex Hospital. Taylor quickly took off in the opposite direction in an attempt to escape.

Although forty-two year-old Taylor denied the charge he was given the death sentence for intent to murder.

A Not So Nice Cup of Tea

In September 1810, a fourteen-year-old servant girl, Elizabeth Hinchcliff, was indicted for attempting to kill Ann Parker, Christopher Stanley and Samuel Smith by placing rat poison in their tea.

Hinchcliff was employed by Ann Parker who lived in Tavistock Row on the east corner of Southampton Street. By the early nineteenth century, most of the houses in Tavistock Row had been converted into shops and, by the mid-1880s, they were all demolished. Parker owned a perfumery shop and a school. Christopher Stanley and Samuel Smith were her boarders.

Hinchcliff had reported a large presence of rats in the house and repeatedly asked Parker for money to buy poison in order to kill them. Parker eventually agreed and Hinchcliff set off to a chemist in the Strand who provided the poison.

Elizabeth Hinchcliff wasted no time in putting the poison to use. She served the tea in two teapots. Ann Parker, who poured tea for some of the children who came to her school, later recounted that, 'I took the cup of tea at one draught, it being cold. As soon as I took

The Hougoumont *was built in the mid-nineteenth century and carried convicts to Australia.*

the cup away, I found a great heat in my throat, and said, "oh! There is pepper in this tea".' The children proceeded to take theirs. Ann then started experiencing pains in her stomach and in her back. By now she believed the girl had played a cruel trick.

One of the five-year-old children then drank the tea and fell sick. As Parker walked across the parlour to get a cloth to wipe up the mess she was seized with a trembling fit. The other child then started to vomit. As Hinchcliff returned Parker asked if she had played tricks with the tea, which she denied. Parker then staggered to the chemists, vomiting along the route. She declared, 'I thought I should never be able to get to the shop, I should die, and the children would die'.

It took two weeks for Ann Parker to recover. In court she claimed that during the twelve months Hinchcliff had worked for her she had 'behaved exceedingly well'.

The chemist and druggist, Mr Midgley, gave evidence testifying to the fact that Hinchcliff had bought the poison from him. All Elizabeth Hinchcliff could offer in her defence was that her mistress ill-used her. The court pronounced the death sentence on fourteen-year-old Elizabeth but it was recommended that mercy be shown on account of her age and her parents being honest people. Two years later, on 25 October 1812, the *Minstrel* convict ship arrived in New South Wales, Australia with 125 female prisoners from England, one of whom was Elizabeth Hinchcliff (*The Women of Botany Bay*, 1988 by Portia Robinson). It was standard procedure on arrival that female convicts were sent directly to the Pramatta Female Factory near Sydney. Some of the women were housed nearby and went to the factory every day for work. Many only remained a day or so before they were assigned to settlers to work as domestic servants.

CHAPTER 2

Bigamy

In an article, 'Bigamy and cohabitation in Victorian England', (*Journal of Family History*, 22, 3 (1997), G. Frost studied 221 cases of bigamy as reported in *The Times* newspaper. He argued that the practice was quite widespread during the nineteenth century. Moreover, society was reasonably tolerant to bigamous relationships as long as certain requirements were met which included having a good reason for leaving the first spouse and an ability to maintain multiple families. Many bigamists, of both sexes, did meet these requirements and this was reflected in the sympathetic way in which courts dealt with such cases. Juries were less tolerant of private prosecutions which threatened to wreck harmonious, but bigamous, relationships. The vast majority of cases show that the spouse concerned had left their first husband or wife for some time before remarrying.

It also appears, from the popularity of novels and stage productions dealing with the subject, that there was a sympathetic attitude to the offence. In the early 1860s, crowds flocked to the *New Adelphi Theatre* to see *The Colleen Bawn,* which dealt with the issue of bigamy, as did Sir Alfred Lord Tennyson's *Enoch Arden* (1864), which sold 60,000 copies in the first few months. Tennyson's poem concerned the character Annie Lee who promised her childhood friends that she would marry them both — and did. Despite the image of the respectable Victorian family, there were often fantasies about the possibilities of having another spouse prevalent in Victorian culture.

These divergent attitudes can be seen, for example, in some of the cases that came before the Old Bailey where punishment varied from short periods of confinement to transportation.

A VERY BRIEF MARRIAGE

Twenty-seven-year-old John Dayer was indicted for bigamy in February 1819. He married Ann Roberts at St George's, Hanover Square (between New Bond Street and Regent Street), in August 1818. However, on 19 October the same year he married Ann Baker at New Brentford church. Dayer never lived with his first wife and in his defence he stated that he never saw her after they had left the church. In the absence of further records we cannot really speculate as to why Ann Roberts had walked out on him straight after the wedding. He certainly did not wait long before marrying his second wife. His punishment was to spend one month in confinement.

A Not-So Fortunate Bigamist

James Hugh Edwards was less fortunate. He married Jemima Hart on 11 November 1809 at St Andrew's, Holborn. Four years later, under the name of Charles Edwards, he married Anna Timson — both lived in the parish of Piccadilly.

In court, Anna's father, James Timson, said that Edwards had visited the house on a number of occasions and had presented himself as a single man. It was only later that the father was informed that Edwards was married and forbade him from entering the house. Anna moved out and went to live in Greek Street, Soho, where Edwards visited her.

The evidence mounted against Edwards, and in court he had to face the families of both women. To add to his dilemma, Anna was pregnant. So how did Edwards explain himself? He stated that the intimacy between Anna and himself had been known to Jemima and added:

I am sorry to have heard the evidence … I do not say there is a conspiracy among the witnesses, some of them having been mistaken, and the other part have not corrected the mistakes; but my innocence or guilt is to be determined by the evidence.

Then in a rather convoluted passage he added:

There has been no positive evidence before the court of any marriage between me and Miss Timson; there is evidence of a person calling himself Charles Edwards and Anna Timson (she was referred to as Susanna by her family), and there is evidence of my marriage with Jemima Hart.

He pleaded with the jury 'to consider the nature of the evidence … all that has been proved is an occasional cohabitation with Anna Timson.'

He could have been accused of splitting hairs in order to save his skin. Despite his pleas, twenty-six-year-old Edwards was found guilty and sentenced to seven years' transportation.

'Quite a Girl'

Mary Ann Rolling was married to Richard Rolling in King's Lynn in 1835. Her friends had described Ann as 'quite a girl'. She lived with Rolling for 'three or four days' and that was all — they never lived together again. Ann left King's Lynn soon after the marriage and came to live in Leicester Square. Five years later, on 6 July 1840, she married Joseph Sapwell at St James' church, Westminster.

The years passed and Sapwell's job caused him to travel a great deal, and after a long spell away — some eighteen or nineteen months — he returned to find Ann living with another man. When he went to claim his property she denied his right to any and said her name was not Sapwell, but Rolling. Sapwell was clearly glad to be out of it, adding, 'I gave her into custody a few days

afterwards: it was for the purpose of ridding myself of a wife that I did not care much about, when I lived with her, we were not happy, I lived in lodgings in Prince's Street, Leicester-square.'

At the Old Bailey on 7 May 1849 she was found guilty of bigamy but recommended to mercy and confined for a period of three months.

THE NOT-SO JOLLY SAILOR

Samuel Taylor, a sailor, married Mary Hayter in 1801. Seventeen years later, at the age of forty, he married Harriet Le Sturgeon at St Ann's, Soho, telling her that he was a widower. Harriet was already pregnant by Taylor who, without warning or reason, left within three months of the marriage. Poor Harriet and child had to resort to St Martin's Workhouse, as Taylor had taken all she had including her clothes. Taylor claimed that he had parted from his first wife by mutual consent. It probably said much about his nature that his first wife had taken in a woman to prevent him from being with her. The court showed little sympathy towards him and he was transported for seven years.

THE BROTHER'S OBJECTION

In 1816, Thomas Mills, who lived in St Martin's Lane, claimed he had quarreled with his wife until he was compelled to leave his home and business to avoid her. Seven years later he wrote to the magistrate to ask whether his wife was still alive. He waited but received no answer, so he concluded she was dead or remarried. His second wife, Ann Pocknell, said that she was not aware that Mills was married or had children. Mills insisted that the relationship was good until Ann's brother brought a prosecution contrary to her desire. Thirty-nine-year-old Thomas Mills was transported for seven years.

'PASSIONATE AND HASTY'

The case of Henry Hamilton in 1844 is, on paper, similar to that of Thomas Mills. Sixty-eight-year-old Hamilton married widower Ann Wilson and lived in lodgings in Covent Garden. When it was discovered that Hamilton was still legally married he defended himself by saying that this was true, and, like Mills, enquired to know if his wife was still living. He found no information and said, 'I took to Ann Wilson'. Once again it seems that it was a relative that took objection to the relationship and in this case it was Ann's son. For her part Ann told the court that her and Hamilton had lived together for more than two years, claiming that 'he was sometimes passionate and hasty with me' but adding that 'my son has interfered'. In this case Henry Hamilton was confined for nine months.

CHAPTER 3
Body Snatching

In eighteenth- and nineteenth-century Britain, criminals, variously known as 'Sack-em Up Men', 'Resurrectionists' and 'Body-snatchers', were loathed and detested for the symbiotic relationship they developed with the equally abominated surgeons. The West End had a number of surgeons and anatomy schools that did business with body snatchers in this grisly trade.

In the eighteenth century, newly established professions such as medical practitioners moved into Soho. By 1850, there were three specialist hospitals dealing with the treatment of venereal diseases and more followed in later years. Additional services were provided for female prostitutes. By 1836, there were three schools of anatomy where corpses were dissected. The most famous was that in Great Windmill Street, established by William Hunter, the eighteenth-century surgeon. The anatomy schools relied on dead bodies retrieved from the gallows, but the demand exceeded supply; the resurrectionists were quick to provide surgeons with bodies.

Body snatchers had resorted to more gruesome methods than merely digging up the bodies of dead people. For example, in 1829, a well-dressed, young, medical student attempted, along with three other students, to seize an elderly woman for the purpose of dissection. The incident took place in St Martin's Lane after they had been fuelled with drink following a heavy session in the Shades tavern, Leicester Square.

Two notorious resurrection men operating in London in the 1820s and early 1830s were John Bishop and Thomas Williams. Bishop had confessed to supplying between 500 and 1,000 disinterred corpses to the London anatomy schools. However, they also confessed to the murder of a number of poor people by administering laudanum in their rum and then suspending them head first into a well in Bishop's garden.

In November 1831, John Bishop, Thomas Williams and James May met in the Fortune of War pub in Smithfield. Bishop and Williams then set off for the West End to try to sell the corpse of an adolescent boy who was lying in a trunk in the washhouse of 3 Nova Scotia Gardens.

The first port of call was to see Edward Tuson at his private medical school in Little Windmill Street, off Tottenham Court Road. Tuson had grown that tired of waiting for Bishop to deliver him the body and he had bought one from another resurrection gang earlier. Undeterred, the two men continued to look for a buyer and went to Joseph Carpue (1764-1848) who had an anatomy school at 72 Dean Street, Soho. Carpue was also

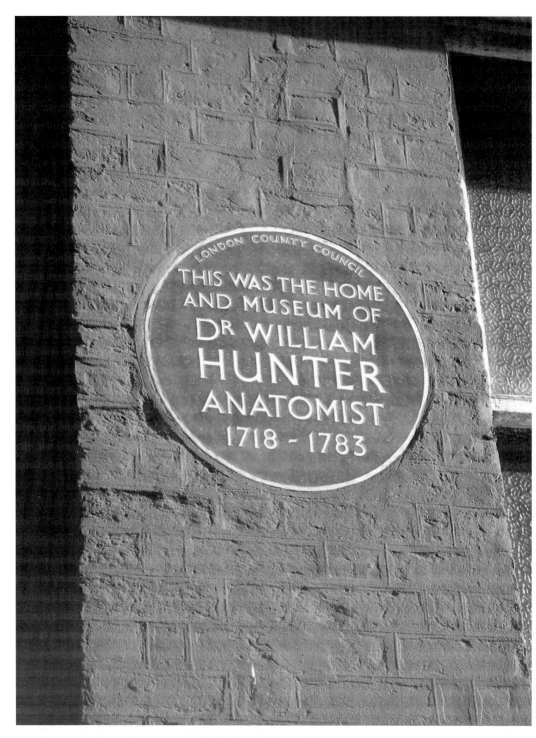

Plaque for Hunter's Anatomy School, Great Windmill Street.

consulting surgeon to St Pancras Hospital. He was described as 'a clever but very eccentric person ... a very good anatomist, who had but few pupils, and carried on his teaching by the very unusual method of catechism' and having 'dirt encrusted hands and nostrils exuding snuff'. When Carpue met Bishop and Williams he spoke to them in the presence of several students and enquired as to how fresh the body or 'thing' was. Eventually Carpue paid 8gn. for the dead boy, which Bishop said he would deliver the next morning at ten o'clock.

Being the greedy pair they were Bishop and Williams returned to the pub and deliberated over whether they could get more money. James May boasted that he had sold two corpses at Guy's Hospital for 10gn. each just the day before. Bishop challenged May to try and sell the body of the boy. Mat agreed and the bargain was sealed. The boy in question turned out to be the famous case of the fourteen-year-old vagrant 'Italian Boy', Carlo Fariere, who, despite his death, contributed to the capture of Bishop and Wiliams (*The Italian Boy: Murder and Grave-Robbery in 1830s London,* Sarah Wise, Pimlico, 2005). The boy, who had lived on Charles Street, Mayfair, was, according to a witness, last seen alive in Oxford Street entertaining in the street and displaying a cage of white mice. Many vagrants performed in the streets around the more well-to-do parts of the West End.

When Bishop, Williams and the other body snatcher, James May, were found guilty of murder at the Old Bailey in December 1831 the news was conveyed to the immense multitude assembled outside. The crowd responded by such loud and long-continued cheering and clapping of hands that the noise carried through the windows of the court. The windows were closed in order that the voice of the recorder could be heard passing the death sentence.

Bishop and Williams were executed outside Newgate in the presence of 30,000 spectators, who cheered 'for several minutes'. The bodies were removed the same night, Bishop to King's College and Williams to the Theatre of Anatomy, Windmill Street, to be dissected. They were publicly exhibited on Tuesday and Wednesday at both places, where immense crowds of persons were admitted to see their remains.

In her book, *The Italian Boy* (2004), Sarah Wise wrote that the dissection of Williams' body at Windmill Street caused a minor riot. The public, for a fee, could go into the dissecting room and watch Edward Tusson and George Guthrie perform their skills on the body. However, students began helping themselves to locks of Williams' hair and some were fighting, in a drunken state, near the body. There was so much noise emanating from the anatomy theatre that it was disturbing the neighbourhood. It was of little surprise that the police tried to stop the whole proceedings. To add to the confusion, there was doubt about the identity of Williams' body because the tattoos were inconsistent to those recorded in the prison ledger in 1827. Plaster casts were made of Bishop and Williams' heads, and the casts were being advertised as late as the 1880s as suitable for private or public museums.

CHAPTER 4
Brothels

Brothels were common in London and particularly in the West End. Henry Mayhew noted that 'we cannot have a better example of this sort of thing than the bawdy-houses in King's Place, St James', a narrow passage leading from Pall Mall opposite the "Guards Club" into King Street'. It was here that men could either take a woman and pay for a room and temporary accommodation or be supplied with women who lived in the house. The women who lived in these houses were completely in the power of the bawds, who grew fat on the business of prostitution.

In the early nineteenth century, brothels varied from the high-class ones in Mayfair to those in the lowest slums of St Giles and Covent Garden. As with the exclusive male clubs around St James', brothels catered for the pleasures of the aristocracy and the well-to-do. So well organised were some of these 'Nunneries' that they could employ surgeons, as in the case of Mrs Hayes' brothel in King Street, to inspect the prostitutes.

The first law that made reference to the term 'common prostitute' was the Vagrancy Act of 1824. Part of the Act stated that 'any common prostitute behaving in a riotous or indecent manner in a public place or thoroughfare' was liable to a fine or imprisonment. The next law dealing with the control of prostitution came in 1839 and was only applicable to London's police districts. It stipulated that 'any common prostitute loitering or soliciting for the purposes of prostitution to the annoyance of inhabitants or passers-by' would be subject to arrest and, if convicted, to a fine, which would increase upon subsequent convictions. Eight years later, in 1847, a similar law (Towns Police Clauses Act) was introduced for the rest of England. These 'solicitation laws' formed the legal basis under which the police in England and Wales controlled unruly women in public. Further changes came after 1885, when Parliament, under immense public pressure, passed the Criminal Law Amendment Act.

A letter to the *Times* in March 1832 expressed concern about the number of women congregating around the Regent Street Quadrant:

Mr. Roe, of Great Marlborough Street, committed some dozen women of the town for not obeying the policemen when desired to leave the Quadrant … Let a law be passed that these unfortunate patrons are not to be permitted to walk the streets at all and then at least they will be acquainted with the laws to which they are subject.

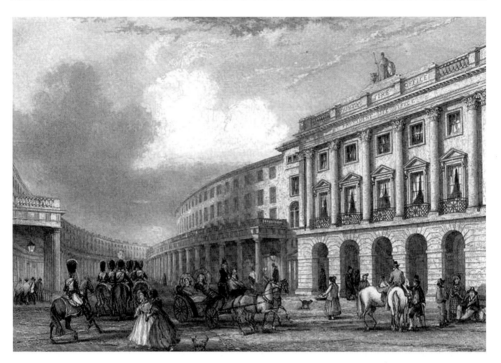

Regent Street Quadrant in 1837 seen from Piccadilly Circus. Engraved by J. Woods after a picture by J. Salmon.

With regard to brothels, it was not until the 1885 Act that the issue was fully addressed. The Act included the 'Suppression of Brothels' section whereby 'any person who kept, managed, or assisted in the management of premises used as a brothel, or was the tenant or landlord of such premises, was liable to a hefty fine or a maximum of three months' imprisonment'. The Act did not, however, define what was meant by the word 'brothel'. However, this was the first major Act to intrude into the private realm of personal sexual behaviour and was an indication of the influence of the growing women's movement.

When most brothel keepers appeared before the courts it was not for keeping a brothel but more likely for an incident that took place in one, such as theft. In the court records many indirect references are made to the use of brothels as well as the criminals who were arrested in them.

John Hale was prosecuted for stealing money in May 1832 from his father James Hale, a hackney coachman. John's mother reported the theft to a police constable, who found the young man at a house known to be a 'common brothel' in Dean Street, Soho. For this offence the seventeen-year-old youth was transported for seven years. Eighteen-year-old Eliza Smith was transported for life for stealing valuables in May 1833 from a Jonathan Lewsey in the Haymarket. Eliza ran off with the stolen goods and was seen going into a well-known brothel in nearby Whitcomb Street. William Humphreys, fifty-

six, was confined for eighteen months in 1850 for demanding 5s from Caroline Ellis, a housekeeper who worked at James Street, Haymarket. In her cross-examination Ellis said that she was still under bail but did not know what she had been charged with. She added, 'it might be for keeping a brothel … I do not understand what a brothel means — men and women come there, they both lodge there, and come there for a short time. I decline to answer whether I allow them to be in a room together. I had much rather not say how much they pay.' Pickpocket John McPherson visited a brothel in Dean Street in 1833 and paid 1s 6d for a room. In January 1835, the police caught two thieves, Joseph Watson and Thomas Edwards, in a brothel in Little Queen Street, Seven Dials. In 1848, witness Elizabeth Butterland was quite frank when she told the court she had kept a brothel for eighteen months in Baker Street.

Those operating in the West End informed much of Henry Mayhew's findings about prostitution in the mid-nineteenth century:

> Convives, or those who live in the same house with a number of others … will commence with those who are independent of the mistress of the house. These women locate themselves in the immediate vicinity of the Haymarket, which at night is their principal scene of action, when the hospitable doors of the theatres and casinos are closed. They are charged enormously for the rooms they occupy, and their landlords defend themselves for their extortionate demands, by alleging that, as honesty is not a leading

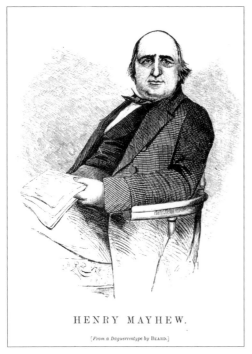

HENRY MAYHEW.

[From a Daguerreotype by BEARD.]

Henry Mayhew, social researcher and journalist who compiled London Labour and the London Poor, *a groundbreaking and influential survey of the poor of London.*

feature in the characters of their lodgers, they are compelled to protect their own interest by exacting an exorbitant rent. A drawing room floor in Queen Street, Windmill Street, which is a favourite part on account of its proximity to the Argyll Rooms, is worth three, and sometimes four pounds a week … They never stay long in one house, although some will remain for ten or twelve months in a particular lodging. It is their principle to get as deeply into debt as they are able, and then to pack up their things, have them conveyed elsewhere by stealth, and defraud the landlord of his money. The houses in some of the small streets in the neighbourhood of Langham Place are let to the people who underlet them for three hundred a year, and in some cases at a higher rental …

One of their most remarkable characteristics is their generosity, which perhaps is unparalleled by the behaviour of any others, whether high or low in the social scale. They will not hesitate to lend one another money if they have it … It is very common, too, for them to lend their bonnets and their dresses to their friends.

If a woman of this description is voluble and garrulous, she is much sought after by the men who keep the cafés in the Haymarket, to sit decked out in gorgeous attire behind the counters.

Mayhew also commented on soldier's prostitutes and how these 'numbers of women throng the localities which contain Knightsbridge, Albany Street, St George's, Portman and Wellington Barracks in Birdcage Walk. They may have come up from the provinces; some women have been known to follow a particular regiment from place to place, all over the country, and have only left it when it has been under orders for foreign service. A woman whom I met with near the Knightsbridge barracks, in one of the beer houses there, told me she had been a soldiers' woman all her life.' (Henry Mayhew, *London Labour and the London Poor*, 1862)

THE FAMOUS DOMINATRIX OF CHARLOTTE STREET

One of the most well-known brothel owners in the West End was the dominatrix Theresa Berkeley. She ran brothels first in Soho and then at 28 Charlotte Street. Her specialty was flagellation and she was notable as the inventor of the 'Berkeley Horse', a notorious machine used to flog gentlemen. Henry Spencer Ashbee (1834-1900), a book collector who amassed thousands of volumes of pornography, described her repertoire:

Her instruments of torture were more numerous than those of any other governess. Her supply of birch was extensive, and kept in water, so that it was always green and pliant: she had shafts with a dozen whip thongs on each of them; a dozen different sizes of cat-o'-nine-tails, some with needle points worked into them; various kinds of thin bending canes; leather straps like coach traces; battledoors, made of thick sole-leather, with inch

Aubrey Beardsley's depiction of flagellation in a gentleman's club in London, 1895.

nails run through to docket, and currycomb tough hides rendered callous by many years flagellation. Holly brushes, furze brushes; a prickly evergreen, called butcher's bush; and during the summer, a glass and China vases, filled with a constant supply of green nettles, with which she often restored the dead to life. Thus, at her shop, whoever went with plenty of money, could be birched, whipped, fustigated, scourged, needle-pricked, half-hung, holly-brushed, furze-brushed, butcher-brushed, stinging-nettled, curry-combed, phlebotomized, and tortured till he had a belly full.

All we know of Theresa's features and personality is that she was attractive with a strong disposition. Her instruments of pleasure were much sought after by the aristocracy and the rich. She was first associated with the famous brothel in Soho, the White House, before moving to Charlotte Street. The reception rooms of the house were garishly decorated; three were known from their fittings as the Gold, Silver and Bronze rooms; there was also the Painted Chamber, the Grotto, the Coal Hole and the Skeleton Room, where, for the delectation of the patrons, a skeleton could be made to step out of a closet with the aid of machinery. Henry Mayhew described some of the bizarre rooms in her brothel and elaborate theatrical sets:

Apartments furnished in a style of costly luxury. Other rooms were fitted with springs, traps and other contrivances, so as to present no appearance other than an ordinary room, until the machinery was set in motion. In one room, in which a wretched girl

might be introduced, on her drawing a curtain as she would be desired, a skeleton, grinning horribly, was precipitated forward, and caught the terrified creature, in his, to all appearances, bony arms. In another chamber the lights grew dim, and then seemed to gradually to go out. In a little time some candles, apparently self-ingnited, revealed to a horror stricken woman, a black coffin, on the lid of which might be seen, in brass letters, ANNE, or whatever name it had ascertained the poor wretch was known by. A sofa, in another part of the mansion, was made to descend into some place of utter darkness; or, it was alleged, into a room which was a store of soot or ashes.

Berkley also enjoyed having a certain amount of torture inflicted on her by her clients — for the right price. She employed women who were prepared to take any number of lashes provided the flogger forked out enough. The women had names such as, Miss Ring, One-eyed Peg, Bauld-cunted Poll, and there was a black girl called Ebony Bet.

There was no shortage of erotic flagellation in Victorian pornography or female flagellants prepared to perform it. The West End was well placed to provide brothels for the well-to-do who would happily pay for the additional erotic and painful pleasures. Henry Spencer Ashbee wrote that:

Very sumptuously fitted-up establishments, exclusively devoted to the administration of the birch, were not uncommon in London ... It would be easy to form a very lengthy list of these female flagellants, but I shall restrict myself to mention a few only. Mrs Collett was a noted whipper, and George IV is known to have visited her; she had an establishment in Tavistock Court, Covent Garden, whence she removed to the neighbourhood of Portland Place ... Then came Mrs James, who had ... a house at No 7 Carlisle Street, Soho. There were also Mrs Emma Lee, real name Richardson, of No 50 Margaret Street, Regent Street ... But the queen of her profession was undoubtedly Mrs Theresa Berkley ... she was a perfect mistress of her art, understood how to satisfy her clients, and was, moreover, a thorough woman of business, for she amassed during her career a considerable sum of money.

When she died in September 1836, she had made £10,000 during the years she had been a governess.

THE ARGYLL ROOMS

The original Argyll Rooms opened in 1806 and stood on the east side of Regent Street on the corner of Little Argyll Street. They were sold to Regent Street Commissioners in 1819 and converted into a place of public entertainment where masquerades, balls and concerts took place. They were burnt down in 1830 when a Mr Braithwaite first publicly applied

The House of St Barnabas in Rose Street, Soho, opened in 1846 and has been helping the poor and homeless for over 160 years.

steam power to the working of a fire engine. These rooms are not to be confused with the later Argyll Rooms on Great Windmill Street, which gained a notorious reputation.

The Argyll Rooms of Great Windmill Street was not a brothel but the wrath they brought from certain sections of society could lead anyone to believe that was the main function of the place. Charles Dickens wrote 'I observe that the Argyll rooms in Windmill Street, Haymarket, is legislatively supposed to be a Music Hall. It is nothing of the sort and was expressively established as a kind of resort that *must* exist somewhere in a great city' — the suggestion being a brothel.

They were leased in 1849 to entrepreneur Robert Bignall, a wine merchant who was well acquainted with the seedier side of the West End. By the following year the Rooms had become established as a resort of prostitutes. The future Prime Minister, William Gladstone (1809-1898), would famously wait and observe outside the Argyll Rooms in his many missions to save fallen women. Gladstone also performed some regular work of charity in the 1840s with the destitute and 'fallen women' who were in or dependent on the House of St Barnabas in Rose Street, Soho. The rooms were closed because they had become a focus for metropolitan vice but they were opened shortly after because it was considered that, on the whole, it was better that the 'vicious population should be brought together than it should be let loose on society'.

CHAPTER 5
Conmen

SHIFTY CHARACTER IN GREEN PARK

Richard Owen was the type of unpleasant character who could clearly turn on the charm when it came to extracting money and valuables from innocent people. He was described as a tall, stout, old man, with a wig and the general appearance of a farmer. In January 1808, he was taking what seemed like a casual stroll though Green Park, but he had some unsuspecting person in his sights. In this case it was an elderly lady who was the widow of a military officer. Owen started up a conversation with her, and as they walked together he pretended to pick up a parcel from the pathway. Feigning surprise, Owen exclaimed, 'what have we here?' The parcel contained a gold cross, apparently set with diamonds, and inscribed on the outside with what looked like a diamond cross. As he was enthusing at the find he 'coincidently' saw a friend, who was clearly part of the stunt. He told his friend that he and the lady had found a diamond cross of some value and were wondering how to divide their good fortune. The friend suggested that they take it to a jeweller to get it valued. Being such a good friend he said he would take it for them whilst they retired to a 'genteel public-house'. The poor woman did not suspect that she was the victim of a scam. Owen's friend eventually returned saying that the jeweller had offered only £40 for the cross, but that he, the friend, was confident it was worth £100.

Owen then told the woman he had to go elsewhere at that moment but would leave the cross with her. For security he asked her if she had any property of equal worth about her. The trusting woman said she had £5 and a gold watch worth £20. Owen agreed that this would cover the value of the cross and also asked her for her address in order that he could recompense her in case the cross was found not to be as a valuable as they believed. Alternatively, if the cross was worth the £100 then he should have the right to claim his share. All was agreed, and the woman left with the cross but without her £5 and gold watch. Predictably, when she took the cross to the jeweller he said it was made of mock diamonds and not worth more than a guinea.

The old lady reported the incident, gave a description of Owen and acknowledged that she had been the victim of a confidence trick. Fortunately for her Owen had been apprehended and the officer told her that if she would go with him to Leicester Square she might be able to identify him, which she did when she arrived there. Owen clearly was not going to go that easy and created an altercation. He protested he had not committed any crime but was quickly silenced and overruled. It transpired that Owen had recently returned from Australia where he had been sentenced to transportation.

He was found guilty of stealing the watch and the money from the old lady and was shipped off once again to Botany Bay. In this case justice was almost done. The woman had the satisfaction of seeing Owen get his punishment and having her watch returned although the money had been spent.

CHAPTER 6
Dog Fights

London's relationship with animals has been such a fundamental part of its history. Animals served many purposes. Livestock were regularly walked through the streets to market where they were slaughtered, horses worked on the roads pulling carts or hackney carriages, dogs were used for the many blood sports that took place or were kept for domestic or entertainment purposes. There is no denying the constant presence of animals in the life of the capital. Baiting and blood sports had been popular for centuries but by the early decades of the nineteenth century they became subject to legislation. The first anti-cruelty act in 1822 covered only cattle and horses, and a more comprehensive law superseded it in 1835. A number of groups also emerged to enforce this legislation, such as The Society for the Prevention of Cruelty to Animals, founded in 1824. Bull and bear baiting was outlawed in the Cruelty to Animals Act, 1835, which also drove dog fighting underground, where it remained popular with the working class and some members of the aristocracy.

Many cruel and sadistic practices involving betting on animals, such as dog fights or ratting (dogs killing rats), continued in the back rooms of pubs or other organized venues. A pub in Compton Street, Soho, advertised, 'Ratting for the Million'. This involved dogs being placed in a large wire pit and killing as many rats in the shortest time possible. Rats, which were always an abundant supply, were usually caught from the sewers, and it was a case of the bigger the better. One landlord told Henry Mayhew (*London Labour and the London Poor* Volume 3. 1851) that 'I should think I buy in the course of the year, on the average, from 300 to 700 rats a week'. In the fights the rules stipulated that any man touching rats or dogs or acting in an unfair way would have his dog disqualified. Officials included a referee and a timekeeper.

In Cambridge Circus, at the intersection of Shaftesbury Avenue and Charing Cross Road, there existed a small dirty place where people would go to the rat pit and bet. The cellar was full of smoke, the stench of rats, dogs, dirty human beings and the stale smell of beer. Gaslights lit the centre of the cellar and a ring was enclosed by wood barriers arranged one over the other. This was the pit for dog fights, cock fights and rat killing. It was usual to place 100 rats into the pit and then bet large amounts of money on whose dog could kill the most rats within a minute. The dogs were efficient, gripping and tossing the rats through the air. The dogs were working terrier breeds, usually Bull Terriers, Fox Terriers, Jack Russells, Manchester Terriers and Staffordshire Terriers. Successful breeders became famous and much sought after.

Cambridge Circus, once the location of a notorious ratting pub.

Mayhew's account of a night at a rat killing typifies such an event.

> ... on a certain night in the week, a pit is built up, and regular ratkilling matches take place, and where those who have sporting dogs, and are anxious to test their qualities, can, after such matches are finished, purchase half a dozen or a dozen rats for them to practise upon, and judge for themselves of their dogs' 'performances' ...
> The front of the long bar was crowded with men of every grade of society, all smoking, drinking, and talking about dogs. Many of them had brought with them their 'fancy' animals, so that a kind of 'canine exhibition' was going on ... The drinking seems to have been a secondary notion in its formation ...
> Whilst the rats were being counted out, some of those that had been taken from the cage ran about the painted floor ... Preparations now began for the grand match of the evening, in which fifty rats were to be killed ... The floor was swept, and a big flat basket produced, like those in which chickens are brought to market, and under whose iron wire top could be seen small mounds of closely packed rats ... When the fifty animals had been flung into the pit, they gathered themselves together into a ... These were all sewer and water-ditch rats, and the smell that rose from them was like that from a hot drain ... presently a boy entered, carrying in his arms a bull-terrier in a perfect fit of excitement, foaming at the mouth and stretching its neck forward, so that the collar which held it back seemed to be cutting its throat in two. The animal was nearly mad with rage ... the

46

A typical ring for ratting from the illustration 'Ratting at the Turnspit Public House, Quakers Alley', artist unknown.

landlord made inquiries for a stop-watch, and also for an umpire to decide ... the dog jumped into the pit, and after 'letting him see 'em a bit,' the terrier was let loose ... In a short time a dozen rats with wetted necks were lying bleeding on the floor, and the white paint of the pit became grained with blood ... It was nearly twelve o'clock before the evening's performance concluded.

CHAPTER 7

Forgers

Until the Forgery Act of 1832 anyone found guilty of forging received the death sentence. Debating the passing of the Bill in the House of Lords in 1832, it was observed that 'the punishment of death had deterred many persons' from committing the crime. The Lords also acknowledged that in 'the seven years ending in 1830, there had been 217 capital convictions, and only twenty-four suffered death'.

FORGERY OF A WILL

Carnaby Market was situated at the west end of Broad Street (now Broadwick Street) in Soho. By the late eighteenth century, mainly tradesmen and shopkeepers occupied the houses on this street. Carnaby Market was closed in 1820 and almost the whole of the area was rebuilt. In 1807, before this rebuilding took place, Abraham Priddy, a lamplighter, lived in the area. His lodger was forty-five-year-old John Almond, an inspector of lamps who earned a salary of about £150. Almond was not the sort of lodger anyone would want. He had lodged there for some time and had managed to famaliarise himself with Priddy's personal circumstances. It was on the basis of this information that Almond planned fraud — for which he paid with his life.

Almond forged the will of Abraham Priddy and then declared himself to be the testator's brother-in-law. The will stated that Abraham Priddy possessed £300 — a sum he discovered Priddy had by asking many personal questions. The will stated that the sum of £50 was to be left to his wife, and two other sums of £50 each to two other persons, who later were proved to have no existence.

Almond had past experience of dealing with wills, as he had formerly been a clerk in the Prerogative Office. Having forged Priddy's mark and declared him to be dead Almond went ahead with his transaction. The will stated, *'Abraham Priddy, testator, formerly of Marlborough Row, Carnaby Market, and Smith's Court, Windmill Street, St James's, late of the hamlet of Hammersmith, died on the 10th* [June] instant (www.oldbaileyonline.org).

Priddy, who was very much alive, gave evidence at the Old Bailey in December stating that he had known Almond for sixteen years. We can imagine Priddy's shock when he paid a visit to the City to receive his dividends for that year only to discover that his stock was gone — even worse, transferred to his lodger! No wonder Almond had tried to talk him out of going to the City that day.

Mary Priddy, Abraham's wife, testified in court saying that Almond had shown great curiosity about what her husband had in the bank. In all innocence she told him that he had £300. It did not take the jury long to pronounce a verdict of guilty. The punishment for forgery was severe, and Almond was sentenced to death. On 20 January 1808, he received his Sacrament, walked onto the scaffold at Newgate and was launched into eternity.

THE BANK-NOTE FORGER

Exactly a year after Almond had been executed another swindler, John Nicholls, would follow suit by also finishing his life at Newgate. Nicholls had established quite an industry in selling forged bank notes. Unfortunately for him, his exploits came to light when an Italian by the name of Vincent Alessi, who lodged at the *Lemon Tree* in the Haymarket, was discovered spending forged £5 notes around the town. When Alessi's lodgings were searched more counterfeit notes were found. After interrogation he quickly confessed that he had bought the notes from John Nicholls, who lived in Birmingham, and had given him 6s for a £1 note, 12s for a £2 note and 30s for a £5 note.

A plan was put in motion to trap Nicholls but this was conditional upon Alessi setting the bait. Alessi had little choice but to play his part. He wrote to Nicholls stating that he was about to depart for America and needed, as soon as possible, 'twenty dozen of candlesticks marked No. 5, twenty-four dozen marked No. 1, and four dozen marked No. 2'. 'Candlesticks' was code for banknotes, and the figure represented the value of the notes. Nicholls replied stating that he would be in town the following week and would provide him with the required sum.

The trap was set and four police officers stationed themselves in a room at the *Lemon Tree*. Nicholls arrived at the time arranged and with the notes. The transaction was then made at which point Alessi put on his hat — the agreed signal for the officers to advance — and Nicholls was quickly secured. When he was searched other forged notes were found on him — he was in an indefensible situation.

In his defence Nicholls tried to argue that the banknotes in question were only to be used outside of England. He claimed that he had never intended that they would be used in the country, especially when the crime carried the death sentence. No one was convinced and Nicholls was given the sentence that he knew and feared he would receive.

HENRY FAUNTLEROY

The interest created in the case of Henry Fauntleroy (1784-1824) in 1824 was of almost unprecedented interest till that time. An intelligent and resourceful man of great charm,

he enjoyed an extravagant and vibrant lifestyle, which included a succession of highly attractive mistresses, all of whom insisted that the price of their companionship was being pampered and showered with expensive gifts. One of these ladies had the impressive nickname of 'Mrs Bang'. Driven by his libido to acts of increasingly excessive generosity, Fauntleroy found himself threatened by insolvency and so drifted into crime.

He had worked for seven years as a clerk at the London bank of Marsh, Stracey, Fauntleroy & Graham in Berners Street, of which his father was one of the co-founders. Fauntleroy was taken into partnership and the whole business of the firm was left in his hands. In 1824, the bank suspended its dealings and on 10 September Fauntleroy was taken into custody and charged with appropriating trust funds by forging the trustees' signatures. Given his reputation, rumours began to spread that he had squandered £250,000 in debauchery.

His trial took place at the Old Bailey on 30 October 1824. The Attorney General was employed to conduct the case for the prosecution and he itemized the various cases of misdemeanors over the years prior to 1824.

The most extraordinary part of the case concerned the damning evidence found among Fauntleroy's private papers, which left him no option but to admit his guilt. In a letter he made the following declaration:

> In order to keep up the credit of our house, I have forged powers of attorney for the above sums and parties, and sold out to the amount here stated, and without the knowledge of my partners. I kept up the payment of the dividends, but made no entries of such payments in our books. The bank began first to refuse to discount our acceptances, and to destroy the credit of our house: the bank shall smart for it.

Henry Fauntleroy wept with much agitation. Seventeen gentlemen of the 'highest respectability' were called to attest to Fauntleroy's character, all stating he was a man of 'honour, integrity and goodness of disposition, and that he was a person whom, of all others, they would have supposed incapable of a dishonourable action.'

He pleaded that he had used the misappropriated funds to pay his firm's debts, but it was not enough to save him from receiving the death sentence. On 30 November 1824, his execution took place at Newgate and it was estimated that nearly 100,000 people turned out. Every window and roof that could command a view of the dreadful ceremony was occupied. One curiosity arising from this execution was that an Italian, Edmund Angelini, offered to be executed in Fauntleroy's place on the grounds that he himself was a much less useful member of society, not being a married man and father like Fauntleroy.

It is claimed that Henry Fauntleroy had the unfortunate reputation of being the last man hanged for forgery. However, Thomas Maynard also has claim to that distinction as he was executed at Newgate on 31 December 1829 for forgery, three years before the Forgery Act, which abolished the sentence of capital punishment for the crime.

CHAPTER 8
Gambling

Debtors' prisons received many thousands of people who had become bankrupt or had lost everything as a result of gambling. Until the 1869 Bankruptcy Act, which abolished debtors' prisons, men and women were routinely thrown into these jails on the say-so of their creditors, and when a man went in his family usually followed him. Although much gambling in the period 1800-1850 was illegal, gaming clubs flourished and the West End became a magnet for them.

CROCKFORD'S EXCLUSIVE CLUB

John Timbs (1801-1875), in his *Curiosities of London* (1867), wrote:

> The name of 'hells,' applied in our day to gambling-houses, originated in the room in St. James's Palace … A few years ago there were more of those infamous places of resort in London than in any other city in the world. The handsome gas-lamp and the green or red baize door at the end of the passage were conspicuous in the vicinity of St. James's; and of St. George's, Hanover-square; and the moral nuisances still linger about St. James's parish and Leicester Square.

Gambling, in various forms, was a regular feature of eighteenth-century London life and prostitution often accompanied it. Gambling clubs thrived in Regency London, and by 1820 there were about fifty of them. Many of them were grouped in the area of Piccadilly and Pall Mall but the hub was St James' Street. In 1845, *Bently's Miscellany* commented that the 'regal, episcopal, and aristocratic parish of St James' has ever been, as it still is, the favoured locality of the speculative and enterprising gaming-house keeper.' In the 1820s, it could boast four of the leading gentlemen's clubs, White's, Brooks', Boodle's, and Crockford's. However, it was the latter that offered its customers a combination of luxurious accommodation, exclusive clientele, and extravagant opportunities for gambling, which was often ruinous. The founder and undisputed king of West End gambling was William Crockford (1775-1844), the founder and proprietor of the establishment bearing his name.

St James' Square, the hub of gambling in Regency London. J. Bowles' view of St James' Square, London c. 1752. The view is looking north.

Crockford began his career as a Fleet Street fishmonger, with a sideline in bookmaking and small-scale swindles. An avid gambler, he bought a share in a gambling tavern in St James' in 1816. However, this had certain limitations for Crockford, who saw greater opportunities in exploiting the pockets of Regency dandies and aristocrats. With a partner he ran Waiter's, a club founded in 1807 by the Prince of Wales, which was well known for its fine cuisine and gambling. Having gained this experience he then opened the exclusive and palatial Crockford's Club on St James' Street in January 1828. Sure enough, it attracted the rich and famous, including the Duke of Wellington; the Lords Alvanley, Bentinck, Chesterfield, Lennox and Raglan; Prince Lieven; Louis Napoleon; and Tallyrand. Some commentators of the time called it 'the leviathan hell'; others noted that behind the charm and splendour there lurked 'unseen, but not unfelt, robbery and wretchedness'. It was the game of hazard, although illegal, that was popular among many gamblers, including bishops and royalty. There was a hazard room upstairs at Crockford's, where those with money played for high stakes, and many wealthy men, such as Lord Chesterfield and the Duke of Wellington, lost huge sums there.

The law did not allow such 'gambling hells', but Crockford managed to escape being raided or closed down despite the large sums of money changing hands. No doubt the very influential clientele played a part in keeping it going.

Crockford, with his cockney accent, played the humble servant role. Nonetheless, after a period of some twelve years his personal wealth stood in excess of £1 million. When he retired in 1840 the number of 'gambling hells' around Piccadilly and Pall Mall had

grown, more than likely inspired by the success of Crockford's. In the same year that he died, 1844, a Parliament Select Committee on Gaming led to a crack down on gambling after a notorious case of bet fixing on the Derby horse race. The 1845 Gaming Act gave the police greater powers to take action against gaming houses and other forms of illicit gambling. The journalist George Sala (1828-1895) recalled how the West End of London swarmed with gambling dens and how gaming booths were dotted around every racecourse, but much of this had gone by the 1860s. Crockford's closed in the same year as the Gaming Act.

It was alleged that Crockford had a system whereby he lured wealthy customers for 'plucking' and, given his fortune, many were well and truly plucked. Today, Crockford's is located in Curzon Street (off the south end of Park Lane) and boasts that it is 'The World's Oldest Private Gaming Club'. It acknowledges its founder William Crockford who 'created an exclusive membership club that attracted the cream of Regency society ... Crockfords in Curzon Street carries forward that tradition into the modern era of gaming.'

HOOK THE HOAXER

To the north of Oxford Street is Berners Street, which, in 1809, was the scene of a cruel hoax on a grand scale. The man behind the hoax was Theodore Hook, who already had a string of pranks to his name. Hook made an audacious bet of £1,000 with one of his cronies that he could make an ordinary house in an ordinary street the most famous address in London for a day. He chose No. 54 Berners Street, which happened to be occupied by a Mrs Tottingham, an innocent woman who he had never met.

Hook set about his task with some energy contacting hundreds of tradesmen of every sort and ordering goods and services to be delivered to No. 54.

In addition, he contacted many other people and urged them to make their way to Berners Street on November 10, the appointed day he hoped to win his bet. The day approached and Hook was anticipating not only winning his bet but also a great deal of entertainment in the process. In order to watch the unfolding drama, he, along with a friend, rented a room in the house opposite.

Even he could not have anticipated the ensuing chaos. At nine o'clock in the morning the first tradesmen arrived and others followed shortly after. They included coalmen with sacks of coal, fishmongers, butchers, bakers, florists, all bearing their wares and jostling each other to get to the front door and then standing around bemused when a very confused and flustered Mrs Tottingham turned them away saying that she knew nothing of the orders concerned.

Throughout the chaotic morning large numbers of doctors, surgeons, teachers, attorneys, hairdressers, vintners and others converged on the house. The neighbouring streets became cluttered with carts of every sort as well as the many tradesmen either

going away crestfallen or standing around confused and angry at having been duped, while latecomers struggled to make their way through the melee to deliver their orders or give their services.

We can only guess at what Hook was making of all this. However, things got even better for him and more embarrassing for Mrs Tottingham when the Archbishop of Canterbury arrived. He had called to collect the large donation he had been promised and he briskly shouldered his way through the increasingly noisy throng, which by now included hundreds of gaping bystanders. The scene must have provided a mixture of entertainment for the onlookers and anger for those who realised their time had been wasted, but more was to follow. The Lord Mayor of London, the Lord Chief Justice and the Lord Chancellor arrived. The chairman of the East India Company arrived on the scene with the same purpose as the Archbishop. The governor of the Bank of England then arrived for his appointment, expecting to meet a criminal who was offering information on a major fraud.

Into this maelstrom of confusion and anger marched a detachment of guards led by the Duke of York, eager to keep their appointment. The neighbourhood was now in a state of total gridlock.

As for Hook, the mastermind behind this extraordinary hoax, he was immensely pleased by the chaos he had created as well as being £1,000 better off. He decided to take a lengthy foreign holiday, paid for by his successful wager!

Berners Street today.

CHAPTER 9
Imposters

THE NAVAL 'OFFICER'

Twenty-two-year-old William Britton, also known as Symer Mark Taylor, was a stout-looking young man who did a very poor impersonation of a naval officer. His purpose was to steal money from other officers. On 17 November 1810, dressed in full naval uniform, he went into the Cannon Coffee-House at Charing Cross and ordered dinner. He asked the waiter if there were any other naval officers in the house. After being informed that there were two or three naval gentlemen staying in the house Britton then ordered a bed. At around six o'clock in the evening, he told staff that he was going to the theatre to see a play.

Three hours later he returned saying that he had left before the end of the performance. He had his supper then retired to his room at half past ten. However, he did not go to his room but to the one next door — that of a Lieutenant Maitland. Unfortunately for Britton the chambermaid was in a room immediately beneath and could hear the noises he was making. When she went to enquire she found that Maitland's trunk had been taken out of his room. She immediately told her master, who went to the room in which Britton was staying but found it locked. Eventually, Britton allowed the landlord to enter and then, in a pathetic attempt to conceal the stolen goods, threw himself onto the bed. He only succeeded in drawing attention to the stolen goods, as well as other valuables, which were scattered about the room.

The landlord acted quickly and locked the room with Britton inside. When an officer arrived they found Maitland's trunk, which had been forced open along with 18gn., 2 foreign coins, some linen and a chisel under the mattress. In court it was said that Britton's 'sorry appearance could have hardly allowed one to suppose that he had ever successfully personated a gentleman'. He was found guilty and given the death sentence, which was later commuted to transportation.

THE 'RECTOR OF FROME'

William Edbrook was landlord at the Quebec Arms on Oxford Street. One evening in July 1811 a customer came in and introduced himself as Tucker, Rector of Frome in Somersetshire. He also added that he was intimately acquainted with 'many personages of the first distinction', that he lodged at No. 42 Green Street, Park Lane, and was curate

of Park Street Chapel. Having established these credentials he then asked Edbrook what wines he could recommend. Edbrook obliged and Tucker ordered two bottles of sherry to be sent the next day to him, stating that his father, sister and some friends were to dine with him. The landlord, pleased with the order, promised to deliver them, and Tucker then departed.

Next day Edrook received another visit from the rector, who drank a bottle of port for which he did not pay. Clearly, Tucker felt he was onto something good and asked if he could have a bed for the night. Although there was no room Edbrook, in good faith, found him a bed in a neighbouring coffee house. The following morning the guest had breakfast at Edbrook's — without paying.

That was the last that Edbrook saw of him until 'Tucker' appeared at Bow Street. His real identity was revealed and he turned out to be a clerk at Park Lane Chapel. He had assisted in the clerical functions at the chapel, complete in gown and surplice, as well as administering the Sacrament to a considerable congregation.

'Tucker', the clerical imposter, was found guilty of falsely obtaining three bottles of wine and money and was sentenced to seven years' transportation.

Bow Street Magistrates Court. The first court was opened in 1740 and a later one (shown) was built between 1878 and 1881, but it closed its doors for the last time on 14 July 2006.

'PRINCESS' OLIVE

People have, for centuries, claimed that they have been related to the royal family. There have been serious pretenders to the throne as well as many fantasists. Today some believe they have a claim to the British crown as descendents of an excluded (but in their view legitimate) line such as the Stuarts. Some individuals have carried off their claim with some degree of success, aplomb or downright stupidity. Olivia Serres was a fantasist who did manage to convince a sufficient number of people of the authenticity of her claim. There is a sympathetic account of her case in the book, *Princess or Pretender* by Mary L. Pendered and Justinian Mallett, published in 1939.

Olivia Serres (1772-1834) claimed the title of Princess Olive of Cumberland. Serres was born in Warwick as Olive Wilmot, daughter of Robert Wilmot, a house painter and known embezzler. When she was young she had a talent for painting and studied art with the marine painter to King George III, John Thomas Serres (1759-1825), who she married in 1791. They lived for a time near Cavendish Square and later in Berners Street. It was a marriage that was doomed not to last. Both were reckless with their money and soon fell into debt, but it was Olive's many affairs that ended their relationship.

Olive then lived with another artist, George Fields, but this also ended and she then turned her energies to painting and writing, producing a novel and several poems. In 1817, at the age of forty-five, Olive wrote a letter to the Prince of Wales claiming she was the daughter of Prince Henry Frederick, Duke of Cumberland (not the notorious 'Butcher' Cumberland but his nephew, a brother of George III) by Mrs Olive Payne (James Wilmot's sister, and her aunt). In the letter she asked the Prince for financial support.

Three years later, she revised her claim stating that her father had secretly married the sister of King Stanislaus I of Poland, and (this starts to get complicated) their daughter had married the Duke of Cumberland in 1767. Olive claimed to be the only child of this marriage and her mother had died of a broken heart as a result of the Duke's bigamous marriage to Anne Horton. Continuing to embellish this story, she added that ten days after her (Olive's) birth she was taken from her mother and substituted for the still-born child of Robert Wilmot.

By the time she had written this revised letter in 1820, King George III had died, which was to her advantage. She argued that George III knew the truth and had given her a yearly pension of £5,000 for life and made her the Duchess of Lancaster when she was one year old. The upshot being that she, so she claimed, was entitled to the income from the Duchy of Lancaster. For good measure she also said that the King of Poland had given her support.

'Princess' Olive had certainly done her homework and she even hired a carriage, which she decorated with the Royal Coat of Arms. To add to the splendour she had a servant dressed in Royal Livery who drove openly through the streets of London. As no action was taken to stop her, rumours spread that she (like Queen Caroline) was a wronged

princess. She later proceeded in state to Drury Lane Theatre, where she was received by the manager and accorded royal honours. Driving to St James' Park in her carriage, she was refused admission at the royal entrance, but on sending a message to the Home Secretary she was allowed to enter. She managed to convince some of the more gullible and in 1821 she was re-baptised as the daughter of the Duke of Cumberland, announcing her ancestry in several letters to the newspapers. Unfortunately for her she was arrested in 1821 for debt and imprisoned in the King's Bench Prison. Placards appeared on the streets reading, 'Princess of Cumberland in Captivity'.

On her release Olive continued to have numerous affairs, one with a fellow imposter, a young man who called himself William Henry FitzClarence, who claimed to be an illegitimate son of the Duke of Clarence. She did not give up on her claims. She even managed to convince an MP, Sir Gerard Noel, to pursue her case. All the evidence was stacked against her when her birth certificate was located and the Polish monarchy declared that none of the king's sisters had ever been to England. The Home Secretary Robert Peel denounced Olive's claims when they were raised by Noel in Parliament in 1823. Despite all this she was never prosecuted for false claims or forgery.

Olive's life was spent in and out of debtors' prisons, but she persisted with her story. She died on 21 November 1834 and was buried on 3 December at St James', Piccadilly. Her daughter, Lavinia Ryves, who called herself Princess Lavinia of Cumberland, continued her mother's case. In 1866, Lavinia went to court with alleged documents claiming over £1 million from the state but these were declared to be forgeries.

Olive had pleaded her claim for so long that she no doubt believed it to be true, as did her daughter. Olive managed to harass, for a while, the British establishment, as well as make many people at least wonder if there was any substance in her claim.

HOTEL JEWEL THIEF

The case of Henry MacNamara bears some similarities to that of William Britton, who had committed robbery in the Cannon Coffee-House at Charing Cross in 1810. On 29 April 1832, MacNamara went to the New Hummins Hotel in Covent Garden and requested a room. MacNamara looked the part, as one of the hotel staff confirmed, saying 'his appearance was such as to lead to a supposition that he was a person of respectability, and there was no hesitation in complying with his desire'. The New Hummins was described as a hotel 'much resorted to by single gentlemen, or casual visitors to the metropolis'.

After taking a hearty supper MacNamara retired to his room — but not for long. In the room immediately beneath slept Major Hampton Lewis. It was around midnight that Lewis was suddenly awakened by sounds coming from within his room. Startled, he looked up and saw MacNamara creeping around in just his shirt and trousers. He was carrying off the major's gold watch, chain and purse. Major Lewis leapt out of bed and

gave chase, eventually seizing MacNamara by his braces in the corridor. After a scuffle MacNamara broke free and ran upstairs. However, the commotion had disturbed some of the other guests and the search for the thief began. By now the police had been called and they entered MacNamara's room. Sure enough, there he was pretending to be asleep. However, in his haste he had leapt into bed still wearing his torn shirt and braces along with his trousers. This had not helped MacNamara's cause, because he had left something resembling a treasure trail consisting of the watch, purse and other items between the major's room and his.

It was not to be MacNamara's night, as four other guests discovered that they too had been robbed of variously a shirt-pin, money, rings, a loaded pistol, purse and a considerable sum of gold. In addition, it was also found that MacNamara had been guilty of other innumerable offences within a very short period, as well as being identified by one of the keepers of Maidstone Jail as having made his escape from that prison, where he had been sentenced for three months as a pickpocket

Predictably, MacNamara was found guilty of all charges, and although the court would have wished to give him the death sentence that was no longer possible for the crimes he had committed. The judgment was that the court 'would be amply satisfied by the permanent removal of this offender from the scenes of his former exploits, and from the opportunities of renewing his depredations'. Consequently, he was sentenced to transportation.

CHAPTER 10
Infanticide

Urban areas experienced high levels of infant mortality in the early nineteenth century. It was not uncommon to discover the bodies of babies in streets or rivers. Life was especially cheap for illegitimate children. It was estimated that there were up to 65,000 unwanted children born each year in mid-Victorian Britain. The superintendent registrar for Marylebone, Dr Bachoffner, found in the mid-nineteenth century that the death rate of registered illegitimates under the age of one ranged from forty-six to ninety-three per cent in his district, making it a particular place of notoriety. The *Marylebone Mercury* reported on a number of cases of infant deaths: a housemaid attending a church service in Manchester Square found a parcel at her feet which turned out to be a dead baby, a charwoman cleaning a house in Bryanston Square found a 'bundle' in the loft which turned out to be the mummified body of a baby, the body of a baby boy floating in a water-butt was discovered after a peculiar taste in the water was reported.

Even in the more fashionable areas of Marylebone there was a high number of multi-servant households. This was reported as a factor for 'baby-dropping' whereby servants could secretly give birth and then dispose of the body nearby. Charles Dickens served as a juryman in January 1840 at an inquest on a case regarding the Marylebone Workhouse, where a young mother was suspected of infanticide. Sympathetic to the girl's plight, he paid for her defence and also helped her whilst she was in prison.

Organizations such as the St Marylebone Female Protection Society were established in 1838 in order to 'reclaim young Women from all parts of the country who have, by one false step, fallen from the path of virtue. They are cared for in their trouble, if expecting to become mothers; and, after suitable training, are placed in service, where needful help is given them in supporting their infants, lest, through want, they should fall again into sin.'

Finding proof of a mother actually killing the child was often difficult. Mary Cope of Brydges Street was acquitted of infanticide in 1835 because the surgeon was unable to state whether the child had been born alive or if its death had been caused by accident or murder.

INFANTICIDE AND THE DOMESTIC SERVANT

In the majority of infanticide cases the defendant received a lenient sentence. However, there were those rare cases where the sentence was heavy. Sarah Perry was unfortunate, as she was typical of many domestic servants who tried to conceal the birth of their child for fear that they would lose their job. In *The Massacre of the Innocents* (1986) Lionel Rose states that the upper classes had the money to conceal their shame and acts of infanticide could be kept out of the public and legal glare whereas the servant occupied an exposed and unenviable position.

Sarah Perry, thirty-three, was charged with the wilful murder of her baby daughter in February 1817. She worked as a cook for a family who lived in Manchester Street, Manchester Square, and shared a garret room with Charlotte Armstrong. Early one January morning, Sarah Perry was taken ill in the scullery. Her roommate went down to see how she was but Perry had closed the door and would let no one in, only saying that she had a pain in her bowels. Over an hour later, Sarah returned to her room and told Charlotte that she had gone downstairs for fear of disturbing her master. Later that morning, Charlotte went into the scullery and noticed blood in the crevices of the stones, in a pan and a washing board. When confronted Sarah replied by saying it was probably from a calf's heart, which she had had to dress.

Charlotte, growing suspicious, told her mistress and then went to Bow Street station. The footman, who had heard the cries of pain, had also heard the sound of a child crying. A few days later the footman and a police officer searched the coal cellar and found a bundle, which had been covered with coals. The bundle contained a newborn female baby with its mouth full of coarse cloth.

A surgeon said he believed that the child had been born alive but could not swear to it. He added that if the child had been alive, the cloth must have suffocated it. Sarah Perry said that she had never had a child before and, being inexperienced, thought she had two months of her time to go. Sarah, like so many domestic servants, kept the birth quiet because she was afraid of losing her job. She was tried at the Old Bailey who found her guilty of murder and sentenced her to death.

Five years later, in 1823, Elizabeth Saunders, a domestic servant who lived in John Street off Oxford Street, was found not guilty of infanticide. She too, like Sarah Perry, gave birth in the kitchen, left a trail of blood and attempted to conceal the child. In this case the infant was found in the privy laying on its back, with the head and part of the neck in the soil — indicating a poor attempt to bury it. There were no marks of violence — a usual sign of murder — and the baby was placed in a box. Unlike Sarah Perry, there was not much conclusive evidence that the child had been born alive. The baby, which was two months premature, was taken to St Marylebone Workhouse and washed. In a pathetic attempt at comfort or remembrance a silk handkerchief was lying by its side. The surgeon who inspected the baby said he thought it might have been born alive, because

he found the lungs inflated, which suggested that it had breathed, although this was not conclusive.

Eighteen-year-old Louisa Wilmot was also found not guilty in 1834 of 'feloniously killing and slaying a certain female infant child'. A surgeon was called to Berkeley Square and found the body of a child in a pail by the girl's bedside. He noted that the child was dead, but warm. Once again no marks were found on the body and the death was attributed to death by suffocation, caused from being immersed in the fluids contained in the pail. The surgeon said that it was 'not at all uncommon for a woman, who delivers herself, to faint and be unable to render herself any assistance at the moment — the death may have been occasioned from that circumstance.'

Maria Poulton, twenty-seven, of Charing Cross, who worked as a cook in 1832, tried to deliver her baby in her bedroom. The pattern was familiar — blood stains, keeping quiet whilst in pain and concealment of the baby in a bundle but in this case the baby was found with tape around its neck. The doctor diagnosed it as a child that was 'well formed in every respect; it had every appearance of having been born alive — of having breathed; there was a bruise on the back of the head, which I consider most probably occasioned by a fall.'

Suspicion was cast as to whether the baby had been strangled but it was difficult to know if the tape had been applied to the neck immediately after death. The doctor's conclusion was typically uncertain: 'it is very difficult to come to any conclusion further than that the child had breathed — it must have breathed several times, no doubt'. Mary was found guilty of concealment only.

A CASE OF EXTREME POVERTY AND DESPERATION

The case of twenty-three-year-old Harriet Longley (aka Eliza Harris) was typical of many desperate mothers. On 19 March 1841, she walked into a police station holding a small piece of bread and saying she wanted to give herself up and confess to the murder of her three-week-old baby, Eliza, whom she had thrown into the river.

Why had she resorted to such a terrible act? Poverty and distress were key factors. Harriet, who had spent time in and out of vagrant wards, had been to Marylebone Workhouse to seek relief, as she had no food or milk for the child. She was refused any such relief and went away and sat in a doorway. The baby cried all afternoon. The surgeon who examined the body of the child confirmed that death was by drowning and there were no other signs of violence, except that the baby was thin and emaciated.

Harriet was found guilty although, in view of her distressed state, the court argued for a strong recommendation of mercy. Her twenty-three years of life had clearly been ones of unremitting misery and hardship.

CHAPTER 11
Kidnapping

STOLEN CHILD

A parent's worst nightmare is the disappearance of their child. Fortunately, in the following case there was at least a happy outcome.

Fourteen-year-old Louisa Wood was a servant to Henry and Martha Porter who lived in Quebec Street near Marble Arch. On 6 June 1817, at six-thirty in the evening, Louisa was out walking near Cavendish Square, taking care of the Wood's six-month-old son, Henry junior. She was accompanied by two other girls at the insistence of Mrs Porter who did not trust Louise to be alone with the child. The girls were approached by a woman who started to admire the child and then gave the two girls a penny, and told them to go and take a walk, which they did. After they had gone, she asked Louise to run an errand for her, adding that would look after the child. After initially resisting, Louise was given 6d for her troubles and set off on her errand to Lower Berkeley Street. When she returned both woman and child were gone. Louise was horrified and quickly rushed off to tell the parents the terrible news.

The kidnapper, forty-five-year-old Harriet Molyneux Hamilton, quickly jumped into a coach with the child and asked the driver to waste no time in taking her to Charing Cross. As they approached their destination Hamilton then told him to continue to the Elephant and Castle road adding 'go gently, as the shaking of the coach frightens the child'. By now the driver must have been wondering what was happening, as he was then told to drive to Croydon. Giving evidence in court he said, 'When we got to Croydon, she asked me to get her a post-chaise; I put her into one at the Greyhound, to go to Reigate, which is the first stage to Brighton; this was about half-past ten o'clock. I got back about half-past four the next morning, and found a child had been lost.' He not only informed Mr Porter about his suspicious passenger but also took him to Brighton.

Eventually, and by good fortune, the woman and child were found at the Golden Fleece in Chichester the following afternoon, much to the relief of a very distressed mother and father. Mr Porter had been informed about the kidnapper and went into the bedroom where he saw Hamilton and his son, who was crying on the bed.

After she was arrested Hamilton understandably anticipated the hostility of the crowd assembled outside the police station and begged to be saved from the mob, which she thought 'would tear her to pieces'. Hamilton claimed that she had meant to return the child to its parents and stated that she had not intended to take the child from its parents forever or to ill-treat it. She also said that she was not motivated by malice towards the child or its parents, or Louisa Wood. Hamilton was sentenced to seven years' transportation.

CHAPTER 12
Manslaughter

Manslaughter is defined as an unlawful killing without premeditation or malice. The crime usually involves deaths resulting from fights or dangerous driving — even in the nineteenth century. Many manslaughter cases in this period concerned deaths resulting from domestic disputes or disciplining servants. The punishments for manslaughter varied from one year's confinement, transportation or a commuted death sentence.

Many manslaughter offences today are the consequence of reckless driving sometimes caused by drink. Roads in the nineteenth century were hugely congested, with traffic consisting mainly of horses, with or without carts; animals, which were taken to market through the streets; and the many people on foot. Without the sort of regulated Highway Code of today, the streets were much of a free-for-all. The growth of London and its many main roads can be seen by a comparison between Greenwood's Map of London for 1827 and Horwood's plan twenty-five years earlier. In 1847, the *Illustrated London News* described the consequences of a traffic jam:

> When some heavily-laden waggon has broken down the long line of carriages of every description are suddenly brought to a stand-still and all are motionless … You see the old thoroughbred London cabman, who has promised to take his fare either east or west, as the matter may be, in a given number of minutes dodge in and out for a few seconds, through such narrow openings … Now there is a slow movement, and the procession proceeds at a funeral pace. The donkey-cart, laden with firewoods, heralds the way, and is followed by the beautiful carriage with its armorial bearings. Behind comes the heavy dray, with its load of beer-barrels; the snail-paced omnibus follows; the high-piled waggon, that rocks and reels beneath its heavy load, next succeeds … the police van rolls on with its freight of crime, and is followed by the magistrate's cabriolet, as he hurries off to a west-end dinner.

With such a heavy volume of horse traffic there was inevitably a huge volume of animal droppings and it was the job of the crossing-sweeper to pave a path for people to cross without fear of getting their shoes or clothes soiled. Arthur Munby (1828-1910), poet, lawyer and diarist, drew attention in his diary for 30 December 1862 to a young girl who had been a crossing sweeper at Charing Cross for several years:

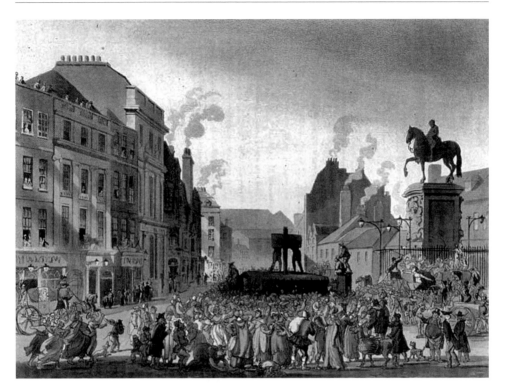

The very busy junction of Charing Coss, which had also been the scene of executions and punishments at the pillory (The Pillory at Charing Cross, as drawn by Augustus Pugin and Thomas Rowlandson for Ackermann's Microcosm of London, 1808-11).

... Margaret Cochrane is ... fourteen, but she looks much older ... She sweeps a path from King Charles's statue to Spring Gardens; the densest part of the wide throng of hurrying carriages. She plies her daring broom under the wheels, which bespatter her with mire as they fly; she dodges under the horses' heads, and is ever ready to conduct the timid lady or nervous old gentleman through the perils of the crossing; she is wet through her thin clothing when it rains; she is in the street all day, the lowest and least protected of that roaring buffeting crowd.

ROAD RAGE

The junction around Charing Cross was still as busy forty years before Margaret Cochrane was sweeping the roads. In this area, in 1820, two days before Christmas, the shop windows were lit, the streets were busy and two coal heavers, William Hughes and William Turney, were driving their wagon of thirty-five sacks of coal along Chandos Street towards Covent Garden at about five o'clock in the evening. As they reached Charing Cross they found that

their path was blocked by a dustman's cart, which stood several feet from the pavement, whilst on the opposite side of the road was a potato cart. The dustman, twenty-six-year-old Joseph Skelton, was collecting waste from a house when Turney asked him politely if he would move his wagon. Skelton responded with some abuse and added that there was plenty of room to pass. Taking him at his word, the two coal-heavers carefully steered past the dustcart but as they did do so they caught the rear end.

No injury occurred but Skelton was so enraged he rushed forward and hit Turney twice in the face, knocking him off the cart and under the wheel. Disturbed by the fracas, the horses started to move and Turney shouted 'for God's sake stop the horses. You have murdered me'. He lay with his arm over his head and his leg was crushed to pieces. People rushed to help and wiped blood from his face. He was carried to hospital where an amputation was performed, but two days later William Turney died in Westminster Infirmary.

Despite his nasty outburst and resort to violence it was deemed that Skelton had not willfully murdered Turney. He was found guilty of manslaughter and confined for one year.

A DANGEROUS DRUNKEN DRIVER

Drunken driving today is a controversial issue, particularly where the punishment of it is concerned. Punishment varies from a ban and a fine to a few years' imprisonment. The long-term effect for the family and friends of the victims amounts to a life sentence. In the nineteenth century, when someone could be hanged for stealing, we might have expected a harsh sentence for death caused by dangerous drunken driving. However, the case of Elijah Gough dispels that image.

Elijah Gough was an early example of a reckless driver who, despite warnings, was driving his vehicle far too fast on a main road. The road in question was Oxford Street. It was at the corner of Bond Street at midday on 25 February 1822 that George Peppitt, a waterman, shouted to Gough to slow down as he sped along in a small cart, with nothing in it, pulled by a single horse. An hour later he came back at full gallop, whipping his horse all the way. Once again Peppitt called, 'For God's sake don't go so fast, you'll run over somebody.'

The awful prediction was about to materialise. Barnard Downs, an old man who walked with a stoop, had swept the crossing between Bond Street and Vine Street for thirteen years. It would be his last day. The cart came so quick on Downs that he turned himself sideways and the shaft attached to the horse's shoulder struck him about the head and shoulder, and shoved him forward about a yard and a half. Then the off wheel went over him, cutting his head open. Gough did not bother to stop but simply whipped the horses harder to get out of the way. The old man was rushed into a doctor's shop and then taken to Middlesex Hospital.

John Holley, a Hackney coachman, said that he saw Gough driving the horse up Oxford Street towards St Giles as fast as it could go. Even Holley shouted 'For God's don't go so fast, you will do mischief'. By now many others had joined in the shouting but he still took no notice until the crowd eventually stopped him. A witness stated that Gough was still flogging the horse to get away. 'I seized both reins and stopped him — he was very violent. The horse appeared in a very bad state; he was as wet as if he had been drawn through a pond.'

Gough was described as being 'tipsy' and ordered to sober up. The surgeon at Middlesex Hospital, John Sweetman, recorded that Barnard Downs had his right thigh broken, and a severe blow on the head and the accident had caused his death.

Forty-year-old Gough was charged of manslaughter and confined for one year.

Runaway Carriage

Another case of out of control traffic, this time without a driver, was reported in *Bell's Weekly Messenger* (28 November 1830). As two young girls were crossing Regent Street, a hackney coach, without a driver, came at a rapid pace, and knocked both the girls down, and injured a gentleman who accompanied them. One of the girls was so badly injured that a policeman immediately took her to her father's residence in Portman Square. The paper added that 'so serious were the injuries she received, that little hopes are entertained of her recovery.' The policeman, in endeavouring to stop the horses, had two of his ribs broken.

A Tragic Christmas

The case of Jonathan Bailey is an all too familiar one of drink and domestic violence. So many of these depressing indictments came before the courts. Bailey lived in Grosvenor Square. On 16 December 1837, he came home drunk but this was a common occurrence as he 'was always intoxicated'. Within minutes the predictable row with his wife began and could be heard by the lodgers. After a short silence there was a scuffle, which lasted some twenty minutes, followed by another silence. An hour later his wife Ann went to see Hannah Cross, one her lodgers, and complained to her of a swelling on her head.

On Christmas Eve the pain was so bad she had to go to bed, and over the next week the agony continued. A surgeon visited Ann on New Year's Eve and found her in a state of 'great danger'. She told him that her husband had inflicted the blow to her head. Four days later she complained that her husband had come into the room and disturbed her, and she said, 'Keep him out of the room, and let me die in peace.' Tragically, she died on the morning of 6 January 1838.

Jonathan Bailey was found guilty, not of murder but of manslaughter, and he was transported for life.

CHAPTER 13

Murder

In an age that appears brutal, with its public executions, punishments and scaffold crowds, most death sentences were not actually carried out. There were many pardons, respited sentences owing to pregnancy, and sentences that were commuted to transportation. Despite the number of offences carrying the death sentence (although this diminished in our period 1800-1850), use of the death penalty was increasingly restricted to the most serious offences. By the 1840s, it was those criminals who had committed acts such as murder, arson, sodomy or violent theft that were sentenced to death. Even some of these had their sentences changed. Under the 1861 Offences Against the Persons Act the death penalty was abolished for all offences except for murder and High Treason.

By the early seventeenth century, there was a thriving market in tabloid-style journalism, where cheap literature supplied an insatiable popular appetite for sensation and titillation. This early literature marked out the beginnings of a genre consisting of tales of sex, blood and gore. Willful murder captured the imagination of many Victorians, who would read the lurid details of such crimes in the newspapers, broadsheets, novels and illustrated papers, such as *The Illustrated Police News*. Such a popular demand for crime would later feed an audience who avidly read the stories of the greatest of all fictional detectives and resident of the West End, Sherlock Holmes, in the *Strand Magazine*. Although crime and criminals, both real and fictional, fascinate us they also repulse us.

A Violent Drunkard

Elizabeth Beesmore was the unfortunate victim of the drunken violence of Thomas Bedworth (1764-1815). Bedworth had been married but this was brought to an end as a result of his wife being involved in a relationship with another man. Bedworth then lodged with Elizabeth Beesmore and their children in Short's Gardens, Drury Lane. Such overcrowded conditions inevitably led to arguments and, as a result of one such row between Bedworth and his son, it was agreed that Bedworth should find separate lodgings. Clearly, his leaving was not just a consequence of a particular row but rather the fact that he was regularly drunk.

It was the result of a heavy drinking session in the Two Spies public house on 20 June 1815 that led to the death of Elizabeth. On leaving the pub he went to the lodgings of his wife and asked if he could lie down and sober up.

Sarah Collis, who lodged with Elizabeth, said that Bedworth asked for some gin (remember he was here to sober up!), which she gave to him. He suddenly pulled out a knife, threw it on the ground and started cursing. After attempts to calm him down Bedworth suggested going home but Elizabeth made the mistake of asking him to stay and see his son, John.

Elizabeth went to get some lace to hold up her husband's trousers. That was the last time Elizabeth was seen her alive. Sarah Collis, giving evidence, stated, 'When I saw her again, it was in about five minutes, at the foot of the kitchen stairs, with her feet up four steps, and her head on the stones. I lifted her up, and her head fell right back on my arm; it was only held to her body by a bit, I immediately ran to the gate, and called murder.'

Surgeon Charles Smithson confirmed the extent of the injuries:

> When I saw her, there was a slight pulsation in her wrist; a very deep wound on her neck; the windpipe was divided; and the carotid arteries as well; she was perfectly dead; and I have no doubt that her death was occasioned by this wound.

An eighteen-page *6d* pamphlet was published in 1815, *The Power of Conscience Exemplified in the Genuine and Extraordinary Confession of Thomas Bedworth*, which sensationally described the savage murder of Elizabeth Beesmore and the trial and execution of Bedworth. The following draws on this account.

> The trial did not last more than an hour as Bedworth had confessed in a written statement that he had 'seized hold of her with his left hand; got her head under that arm, and with a shoemaker's knife which he brought from his own lodging for the purpose, cut her throat, and she dropped dead from him without making any noise, on which he ran away, taking the knife with him, which he threw away the next morning into the Regent's Canal.

Bedworth had served his country by fighting in the navy against the French between 1804 and 1813, but now he was facing his moment of disgrace and judgement. His confession brought with it the inevitable death sentence. The judge solemnly announced that 'your time in this world is of very short duration ... but it is not too late for repentance and for pouring out your soul to your maker.' It was noted that Bedworth lifted his eyes towards Heaven, struck the bar with his hand and, bursting into tears, bowed in assent to the remark. The judgment also added that after his execution his body would be delivered to the surgeons where he would be anatomized and dissected.

The following Monday morning at Newgate, the crowd that had assembled to 'witness the execution was very considerable'. At three minutes to eight Bedworth walked to the scaffold with 'great firmness and resignation'. He requested that his leggings be given to a fellow prisoner in order to protect his flesh from excoriation by the fetters. After the usual regrets of a sinful life and forgiveness for the crime he had committed the bell tolled and he moved toward the scaffold with his eyes fixed towards heaven. He was then launched into eternity.

TRAGEDY AT THE SCAFFOLD

The area around Marylebone Fields and the Basin was notorious for criminal activity. Just north of Cavendish Square between Queen Anne Street and Weymouth Street was a large reservoir known as the Marylebone Basin, which became a place for bathing by the eighteenth century as well as supplying water to the water works at Buckingham Place and the Strand. The Basin was drained between 1764-6, which gave way for the development around Mansfield Street and the elegant Portland Place.

Marylebone witnessed a number of well-known murder cases. Elizabeth Godfrey, twenty-six years of age, was executed for stabbing Richard Prince with a knife in the left eye, of which 'he languished and died', on Christmas Day 1806 in Marylebone parish. At her trial she was described as 'dressed in white, with a close cap: she wore long sleeves: she appeared much dejected, and sensible of her situation.' On 23 February 1807, she was hanged at Newgate.

That was not quite the end of the story, as there was an awful turn of events at the scaffold. Elizabeth Godfrey was hanged along with two other murderers, John Holloway and Owen Haggerty. On the day of the execution it was estimated that up to 50,000 people turned out to witness the spectacle. As the three condemned mounted the scaffold the crowd pushed forward eager to hear the condemned say their last words, as well as to get a better view. The pressure proved so great that around 100 people were trampled underfoot. Thirty-five people died and the bruised and maimed were taken to St Bartholomew's Hospital. A contemporary report commented that 'the shrieks of dying men, women and children, were terrific beyond description, and could only be equalled by the horror of the catastrophe.'

THE SAD CONSEQUENCES OF HEAVY DRINKING

On 10 January 1818, Issac Davies had spent a heavy night drinking with his friend David Evans. Evans did not have too far to stagger home, as the pub was next door to his house in Crown Street, St Giles.

Next morning Davis went to call on his friend at his house and, out of courtesy, asked how Mrs Evans was. David Evans replied that she was in bed, which then prompted Davies to look in on her. Teasingly, he commented, 'Mrs Evans, it is a fine time of day to be in bed' but there was no answer. As Davies looked closer he saw her lying on the bed with her mouth half open. He then alerted her husband with the cry, 'Mrs Evans is dead'.

Evans responded with 'Good God don't say so' then quickly ran to the bed and started to cry when he saw her. His friend asked him when he last spoke to her to which Evans answered between six and seven o'clock that morning. He added that her feet were very cold, and he had put a hot brick to them to which she had murmured, 'that is a good boy'.

Probing a little more, Davies asked if he had done anything to his wife Elizabeth. His answer was not wholly satisfactory saying, 'No, but I was very much intoxicated — I don't know what I did ... [she] was aggravated by some of the lodgers who it seems were very drunk.' He then recalled that one of the women of the house told him that his wife had had 'connection with one of the lodgers in the passage'.

What had happened between that drunken night of 10 January and the early hours of the next morning? Ann Desmond, a lodger who lived in one of the back rooms, managed to cast some light on events. She recalled that Evans had taken a drop too much as he had argued with her husband. As she returned to her room she then heard Evans shouting abusively at his wife about some money, asking her what she had done with it. As Ann Desmond crept out of room to hear more clearly she heard him beating Elizabeth Evans 'dreadfully'. 'I cannot tell what he beat her with but it appeared to be with some weapon. I heard her say "Oh! Dear me," and "don't" several times.' Having listened to this distressful scene for about ten minutes she ran back to tell her husband but he was too drunk to respond. Desperate to alert people to what was happening she tried knocking next door but to no avail. She reluctantly decided to go back to her own room in the hope that the violence would stop.

At ten o'clock next morning, Ann plucked up the courage to go and investigate. She knocked on the door from where the screams had been coming and Evans answered holding a cloth in his hand as if 'wiping something off the floor'. Another lodger, Rebecca Mickelwhite, said she heard Mr and Mrs Evans arguing and shouting for over an hour, which was then followed by three distinctive groans.

By the time Evans had sobered up he was consumed with guilt and regret. Witness Ann Davis asked him why he had not called anyone when he knew his wife was so bad. Evans replied that he did not know what he did; he was locked in and could not get out. As other neighbours became involved they tried to clean up the body of Mrs Evans although it appeared that her husband had already attempted to do this. Leah Madden, another witness, said, 'I saw her on the bed; she was cleaned and naked. She had a clean shift on, and her mouth was tied up' although, apparently, there were many bruises on Elizabeth Evans.

When a constable was called Evans admitted to being drunk and admitted that he had argued with his wife over the incident in the passageway with another man. He said he had struck her on her mouth with his hand but could not recall using anything else, as he had been intoxicated. The policeman noted that there was blood on the mantlepiece and some had splashed upon the wall. 'There was a great deal of blood on the handles of the drawers in the front room, and blood on the floor ... The fender, poker and shovel had blood on them — the poker was bent'. A surgeon confirmed the injuries adding that a blunt instrument must have made them.

In court, Evans, who had little to offer in his defence, was sentenced to death.

ARSON AND MURDER

Jonathan Smithies owned a tobacconist shop on Oxford Street that he had insured for £700. The blind greed of this man to claim the insurance caused the tragic deaths of three people. On a Monday morning, 28 May 1832, a fire broke out in the lower part of his house. The police had seen a conflagration in the lower part of the house and proceeded immediately to the shop, where they found Smithies trying to escape from the kitchen into the street. His attempt proved fruitless and he was compelled to go back through the kitchen and make his way up the stairs, which were on fire. He finally succeeded in reaching the street, much burned about his face and hands and with his clothes on fire.

The sudden admission of air into the house through the shop door increased the fury of the flames, and before other people who were asleep in the house could hear any alarm nearly the whole of the lower part of the premises was on fire. Smithies was immediately taken to Middlesex Hospital to receive treatment to his wounds.

Meanwhile, the unfortunate lodgers in the house tried to escape by the stairs but this proved impracticable. The scene that followed was harrowing to the bystanders in the street. At almost every window were to be seen persons, male and female, bewailing their dreadful situation, and imploring aid with uplifted hands.

A servant-girl at the third-floor window desperately made signs that she would throw herself into the street, but the crowd tried to encourage her to descend to a lower floor before she made so hazardous an attempt to save her life. With great difficulty she fled to the second-floor front room. Outside, several men stood under the window ready to catch her. The girl summoned up the courage to throw herself out, where she was safely caught in the arms of one of those below.

This was one of the more successful stories. What followed was much worse.

The second floor of the house was occupied by an elderly woman, named Twamley, and her family of two daughters, Eliza, who had been a dancer at Covent Garden Theatre, and Caroline; an orphan boy, about eleven years of age; and a Miss Thomasin, their niece.

When it became clear that all hopes of their escape by the staircase had vanished they ran from window to window in a desperate state of mind. Terror-stricken, Eliza Twamley held the boy in her arms and remained at the window, unable to adopt any decisive course, until at length the flames caught what clothes she had on. Seventy-year-old Mrs Twamley suffered from chronic asthma and was unable to get out of bed. Her daughter Caroline heroically tried to save her from the impending danger. She seized her in her arms, raised her from the bed and helped her through the window to the rear of the house, from which she hoped to escape.

She soon attracted the attention of some of the neighbours who grabbed a nearby ladder which they raised against the wall near to where she stood, but at that moment Caroline and her mother fell about fourteen feet. Attempts to give medical aid to Mrs Twamley were in vain and she died within two hours. Caroline, although safe, was in need of medial attention.

On the following day a coroner's inquest was held, and in the course of the inquiry disclosures were made which pointed to the suspicion that the house had been willfully set on fire. Guilt fell on the prime suspect, Jonathan Smithies. Further evidence showed that ten days previous to the fire he had purchased two sacks of wood shavings, which had been left in a vaulted cellar at the back of the house, with a quantity of old baskets and boxes and other rubbish. Further investigation showed that the fire had originated at the bottom of the kitchen stairs, where the remains of burned shavings were distinctly visible. In the back vaults, adjoining the kitchen, there was even stronger proof. Gunpowder pressed into a card was found leading to a heap of shavings at one end and to a mass of easily ignitable rubbish at the other.

The orphan boy, named Charles Farengo, subsequently died from the injuries he had received. The coroner's jury had no hesitation in returning a verdict of willful murder against Jonathan Smithies who was in custody but still receiving treatment in Middlesex Hospital. His trial began on Friday 6 July, where he was charged with the murder of Eliza Twamley and Charles Richard Napoleon Farengo. Mrs Twalmey's death had been caused by fear. Smithies was found guilty and the death sentence was immediately pronounced; his execution took place on Monday 9 July 1832.

THE BUTLER DID IT!

The stabbing to death of Lord John Russell (b.1767) in 1840 by his twenty-three-year-old valet, Francois Benjamin Courvoisier, was described as one of the most high profile murders of the nineteenth century. This took place in Mayfair, the kind of desirable neighbourhood not readily associated with violent crime. A frenzied attack had taken place, during which Russell's head had been almost severed from his neck.

Lord John Russell was a member of the British aristocracy and longtime MP for Tavistock. His career was not a particularly notable one. He lived alone in his house at 14 Norfolk Street (now Dunraven Street) off Park Lane, Mayfair, with a household of servants; a housemaid, Sarah Mancer; a cook, Mary Hannell; his valet, Francois Benjamin Courvoisier; and a coachman and groom, all of whom lived in the house, except for the last two. The house was small and consisted of only two rooms on a floor. Russell was a member of Brooks Club, in St James' Street, and usually spent most of the day there. He generally dined at home, read for a while and went to bed at about midnight.

The valet had been employed for only five weeks; he had told his fellow servants that he didn't like his master, and had said that if he only had the money he'd go back to Switzerland.

On 5 May 1840, Lord Russell returned home from his club, had dinner at seven o'clock, followed by coffee and, at about nine, retired to his library. Around half-past ten

the women servants went to bed leaving Courvoisier to attend to his master. At half-past midnight Russell rang the bell for help in getting ready for bed.

It was not until after half-past six the next morning that the awful discovery was made. Sarah Mancer, the housemaid, went downstairs, and found furniture strewn about and drawers and boxes open. The room was in such a mess she thought burglars must have been in the house during the night.

Sarah went to tell the cook what had happened and the cook told her to tell the valet, which she did. She followed Courvoisier to check on their master in his bedroom. Courvoisier went to the window to open the shutters, but Sarah went to the bedside and saw the pillow saturated with blood and Russell lying in bed, dead, with his throat cut.

After a detailed examination the police concluded that someone in the house, who had faked a robbery, must have committed the murder. The state of Lord Russell's bedroom confirmed all suspicions. A jewellery box and a notecase had also been opened, and several articles of small value taken, including a ten-pound note and a purse that contained gold. It was not long before Courvoisier came under suspicion although none of the stolen goods were discovered in his room.

Three days later a police officer examined the floor, the skirting board and the sink. Behind the skirting-board he found five gold rings which had belonged to Lord Russell, as well as five pieces of gold coin and a piece of wax, a Waterloo medal and the ten-pound note. The discovery was taken as conclusive evidence of the valet's guilt. Courvoisier was taken into custody.

His trial took place on Thursday 18 June at the Central Criminal Court. A big collection was raised from foreign servants in London to pay for Courvoisier's defence. The case had caused great attention and the court was crowded with members of the aristocracy, ambassadors and diplomats. Courvoisier was a foreign national, but he chose to be tried by a British jury and pleaded not guilty.

Despite his plea of not guilty he had to change it once the evidence began to mount up against him. The evidence showed that some articles of plate were removed from the house before the murder. Although the police had not been able to find this stolen property it was discovered to be in the possession of Madame Piolaine, the keeper of a French hotel in Leicester Place, Leicester Square. When Courvoisier was told this he at once admitted his guilt. His defence had hoped to implicate the female servants, but this now had to be abandoned.

On the following day Courvoisier made a full confession, saying:

His Lordship was very cross with me and told me I must quit his service. As I was coming upstairs from the kitchen I thought it was all up with me; my character was gone, and I thought it was the only way I could cover my faults by murdering him. This was the first moment of any idea of the sort entering my head. I went into the dining-room and took a knife from the sideboard. I do not remember whether it was a carving-knife or not. I then

went upstairs, I opened his bedroom door and heard him snoring in his sleep; there was a rushlight in his room burning at this time. I went near the bed by the side of the window, and then I murdered him. He just moved his arm a little; he never spoke a word.

Those who wanted to watch the execution while enjoying greater comfort paid £2 for most of the windows overlooking the scaffold at Newgate. For £5 additional amenities were on offer when renting a window in Lamb's Coffee House. Many well-to-do voyeurs parted with good money that day and one extremely modish lady managed to fall out of the window onto the crowd below, such was her anxiety not to miss the action. William Makepeace Thackeray (1811-1863), the novelist, was not a habitué of hangings but went to see that of Courvoisier and described it graphically in an essay, 'Going to see a Man Hanged'. The event left him with feelings of shame, revulsion and fear. In an article published in *Fraser's Magazine*, he wrote:

Before us lies Newgate Prison ... There it stands, black and ready, jutting out from a little door in the prison. As you see it, you feel a kind of dumb electric shock ... After the gallows shock had subsided, we went down into the crowd, which was very numerous ... The character of the crowd was ... quite festive — jokes bandying about here and there, and jolly laughs breaking out.

As the clock began to strike, an immense sway and movement swept over the whole of that vast dense crowd ... and a great murmur arose, more awful, bizarre, and indescribable than any sound I had ever before heard. Women and children began to shriek horridly ... and lasted for about two minutes.

Just them, from under the black prison-door, a pale, quiet head peered out. It was shockingly bright and distinct. It rose up directly, and a man in black appeared on the scaffold, and was silently followed by about four more dark figures ... "That's he — that's he!" you heard the people say ...

Courvoisier bore his punishment bravely. He was dressed in a new black suit, and open neck shirt. His arms were tied in front of him and 'his mouth was contracted into a sort of pitiful smile'. He stepped onto the gallows with his face towards St Sepulchre's. The executioner, dressed typically in black, twisted him round swiftly in the other direction, and drawing from his pocket a nightcap, pulled it tight over the condemned man's head and face.

The witness wrote:

I am not ashamed to say that I could look no more, but shut my eyes as the last dreadful act was going on, which sent this wretched, guilty soul into the presence of God ... Forty thousand persons of all ranks and degrees — mechanics, gentlemen, pickpockets, members of both Houses of Parliament, street-walkers, newspaper writers gather together before Newgate at a very early hour.

Charles Dickens witnessed the same hanging and was surprised to pick out Thackeray in the milling crowd. However, at six feet three inches, Thackeray must have been quite conspicuous. Dickens found the scene absolutely sickening and concluded that public executions were cruel and barbaric and demeaning for the spectators. He believed that executions were necessary but should be carried out behind closed walls.

THE MAN WHO BELIEVED HIMSELF TO BE PRINCE ALBERT

In October 1843, twenty-eight-year-old William Stolzer was indicted for the murder of a boot-maker, Peter Keim. According to Maria Nelson, a witness, Keim was running very quickly near Broad Street, Soho, holding his hand to his stomach and shouting 'murder'. Following him in hot pursuit was Stolzer holding a knife and smoking a pipe! Shortly behind Stolzer was a policeman in a scene that must have resembled a tragic farce. Eventually, Stolzer was seized and taken into custody.

The interestingly named police constable Jesse Jeapes said that the prisoner was brought to Vine Street station but no charge was made against him, and he was sent away. However, shortly afterwards the police received information about Stolzer which prompted them to look for him. They found him within half an hour hiding in a water-closet 'lying on his back, with a silk handkerchief tied very tight round his neck, and a little blood and froth coming from his mouth'. He was then taken back to the station.

A surgeon, Peter Marshall, who lived in Greek Street, Soho, examined Peter Keim and found a wound on the lower part of the belly that had been inflicted by a knife. Keim lived for a few hours before dying.

What had caused Stolzer to murder Keim? William Henry Rotton, with whom Stolzer had lodged, recalled that one night Stolzer had burst into his room with 'a mad look, as if he was not in his right mind' and begun telling a story about a friend of his who was in the habit of coming to see him and some other Germans that had lodged in the house twelve months before. Rotton eventually managed to get rid of him but was clearly concerned about Stolzer's state of mind and so made moves to remove him from the lodgings. Rotton thought he might have seen the last of his lodger until the night the policeman came to the house and found Stolzer hiding in the yard.

Had Stolzer simply lost his mind and took it out of Keim? Stolzer's state of mind was confirmed as being 'weak' and his employer said that 'every person in my place, the girls particularly, joked and laughed at him'. He also added that Stolzer fancied himself to be Prince Albert.

It seemed that all the warning signs that Stolzer was likely to do something dangerous and irrational were confirmed when his brother warned another lodger that he 'should be careful of him'. With this information the lodger became particularly vigilant and worried, especially when he noted that Stolzer was sleeping with his head at the foot of the bed, his feet about four feet above the pillow, and going out without his boots on.

Stolzer was clearly not of sound mind but he was still given the death sentence. However, as with so many condemned to death, his sentence was transmuted and he was transported for life. How he behaved on the voyage or when he arrived in Australia we do not know but no doubt his fellow convicts gave him a wide berth.

A Savage Murder

William Crouch, twenty-eight, lived in Great Chesterfield Street, Marylebone, with his wife, Frances Elizabeth Crouch. Their relationship eventually became strained and she moved and lived about forty yards away. On the night she left him he told one of the lodgers, 'I will lie awake for her, and give her a good hiding; and if I had her here, I would cut her throat with a razor'. Two weeks later, on Saturday 30 March 1844, he came home after a drinking session and was heard to be saying repeatedly, 'it must be done, it must be done, I cannot wait'. At about seven o'clock in the evening, he went to where Frances was staying, stormed up the stairs and asked a cleaner, 'is my mistress upstairs?'

Frances was in a good mood and could be heard singing. That stopped very quickly as Crouch burst through the door into her room. Hearing a child screaming, a lodger rushed to the room and found Crouch standing with his left arm against a chest of drawers, wiping a razor. Frances was lying dead, bleeding from the throat with the child lying alongside her. It was later discovered that the cut was so deep that it was only the spine that kept her head attached to her body. Crouch was still in an agitated state and was shouting threats to his dead wife. He then turned and walked out as fast as he had entered. The lodger gave chase and stopped him with the help of the landlord. A policeman soon arrived at the scene. Crouch asked if his wife was dead and then added, 'I could not help it... it serves her right; she had no business to have left.'

Despite this outburst of venom Crouch was soon repentant, saying that he wished he were dead. He cried and asked to see the child. The investigation that followed attempted to assess Crouch's state of mind, as he was known to have fallen from a horse when he was in the forces and this had caused some damage to his brain. One surgeon said that he knew Crouch before he had this accident and he was a 'very civil, good tempered, active man' but after the fall 'he was in a state of great weakness of mind.'

The court considered much evidence about Crouch's mental state but decided his callous act was premeditated and sentenced him to death. On 27 May 1844, he was executed at Newgate.

CHAPTER 14
Obscene Publications

Anxieties about the behaviour of the working class had long been a concern for those in authority, and as early as the seventeenth century moral campaigners, such as the Societies for the Reformation of Manners, were formed. Others followed, including The Society for the Suppression of Vice. This society was founded at the suggestion of William Wilberforce in 1802 and was responsible for some fifty-five prosecutions between 1802 and 1824. Its primary target was foreign-hawkers who sold obscene publications on the streets. The society succeeded in adding a clause to the 1824 Vagrancy Act that mandated a summary trial before a magistrate for anyone caught exhibiting obscene prints or books in public places. One publication, *The Leisure Hour*, in January 1872, described the Society for the Suppression of Vice in the following terms:

> It laboured unremittingly to check the spread of open vice and immorality, and more especially to preserve the minds of the young from contamination by exposure to the corrupting influence of impure and licentious books, prints, and other publications, its difficulties have been greatly increased by the application of photography, multiplying, at an insignificant cost, filthy representations from living models, and the improvement in the postal service has further introduced facilities for secret trading which were previously unknown.

In 1822, the society was instrumental in arresting William Benbow (1784-1841), proprietor of The Byron's Head bookshop in Castle Street, near Leicester Square. The poet Robert Southey sanctimoniously described Benbow's shop as 'one of those preparatory schools for the brothel or the gallows; where obscenity, sedition, blasphemy are retailed in drams for the vulgar.'

Benbow was a lifelong radical. He moved to London where he helped William Cobbett on the radical newspaper *Political Register*. The authorities arrested Benbow in their effort to stop the *Political Register* from being published. He was tried and found guilty of seditious libel but continued his radicalism becoming a Chartist and believing that equality could only be achieved through violent revolution. Benbow was yet again tried for sedition at Chester in April 1840 where he spoke for ten hours in his own defence, but he was found guilty and died in prison in 1841.

The Society for the Suppression of Vice was provided with a rich seam of licentious activity in parts of the West End where bookshops and publishers flourished and were happy to sell what the public wanted. Holywell Street, off the Strand, was once noted for booksellers' shops and became known as Bookseller's Row. It was extremely popular because in 1834 there were fifty-seven shops dealing in pornographic material. However, it was felt that shops dealing in such lurid material encouraged a dangerous promiscuity and The Society for the Suppression of Vice campaigned against the availability of such corrupting 'filth'. A measure of their success was reflected in 1857 with the passing of the Obscene Publications Act.

Thomas Dugdale, twenty-six, had worked with Benbow and owned a shop in Holywell Street. In July 1847, George Sharp, a solicitor's clerk, was instructed by the Society for the Suppression of Vice to investigate publications in Dugdale's shop. Amongst the stock they found 'books to excite the passions'. Dugdale was found guilty of unlawfully selling and publishing obscene prints and sentenced to confinement for one year and ordered to pay a fine.

CHAPTER 15
Quacks

Quack doctors are charlatans associated with fraudulent medical practices who pretend to possess skills or qualifications they do not actually have. They have existed for centuries and exploit a gullible and often desperate public. Some quacks prospered through their chicanery and many others peddled ineffective, and sometimes dangerous, treatments. They made claims to miraculous cures with their worthless pills and potions. Despite the Apothecaries Act of 1815, which defined the legal requirements for the general practice of medicine, it did not prohibit what might be called irregular practice.

The London Guide of 1818 warned people, especially visitors to London, against the prevalence of many 'cheats, swindlers and pickpockets'. Included in these was the abundance of, 'nostrum-mongers who prepare some *panacea*, that will cure various and discordant disorders; thus playing with the lives ... health and happiness of those who harken their advice. Whoever has been unfortunate enough to consult a certain loathsome disease, should be upon their guard against pretended doctors.'

The newspapers of the day advertised cure-alls and elixirs and there were many shops that sold such potions. In 1812, Thomas Collicott, who was indicted for forgery, kept a shop in Oxford Street that sold 'quack medicines'.

Marylebone attracted many branches of the medical profession. Harley Street, which began its history in 1729, is one of London's most well-known streets and is synonymous with medical practice. It was well placed and fashionable enough to attract wealthy residents with the older, established Oxford Street to the south and a network of other important streets being constructed, such as Baker Street and Portland Place.

One notorious practitioner was John St John Long (1798-1835). Born in Ireland as John O'Driscoll, he arrived in London in 1822. Without medical training (he had tried to establish himself as a portrait painter) he set himself up in a practice in Harley Street. He claimed to have invented a liniment that could cure consumption as well as a 'rubbing lotion' that could treat tuberculosis. His methods were those of a charlatan. Such was his reputation he became known as the 'King of Quacks' because of his many cure-alls and dubious methods. Long's use of lotions and inhalants, which involved yards of mysterious pink tubing, and his private massage sessions presented a novel alternative to the medicine provided by many of the other practitioners in Harley Street. Nonetheless, he soon became fashionable and wealthy, and his practice attracted many wealthy women who earned him some £12,000 a year by the late 1820s. He had the advantage of good looks and charm,

William Hogarth's depiction of
quackery in the eighteenth century in
Visit to the Quack Doctor.

Typical bottles of elixirs and cure-alls
used by quacks.

Charlatan John St John Long, who
was adored by many women.

both of which clearly contributed to his success. All went well until a number of patients began to suffer with extreme side effects and two young women died as a result of his 'unique' treatment; two cases of manslaughter were brought against him.

It was in August 1830 when a wealthy woman named Cachin and her two daughters came to London from Dublin for the purpose of procuring medical assistance for one of the daughters, who was suffering from consumption. She had heard of the wonderful cures of St John Long, so she had no hesitation in seeking out his advice and aid for the girl. In cases of internal disease his treatment involved creating an external wound and a discharge to carry off the malady. However, in this particular case the external wound became so bad that the landlady, Mrs Roddis, felt sufficiently concerned to act on behalf of the young girl by warning her of the dangers involved. St John Long's response was to laugh off this suggestion, and he declared that the wound was healing remarkably well. As each day went by the health of the girl deteriorated and she became so seriously ill that the services of an eminent surgeon were called for. Unfortunately, the problem had gone far beyond any possibility of a cure and, tragically, the girl died. The post-mortem of Mrs Cachin stated that she was a 'perfectly healthful subject, beautiful in form and free from all disease, save that occasioned by the wound in her back.'

The coroner's inquest brought forward a number of witnesses who had been patients of Long, for different diseases, and to whom the same mode of treatment had been applied. They all spoke of the advantageous effects of this treatment and how it had benefited them. Nonetheless, Long was charged with manslaughter and committed to Newgate to await his sentence. The sentence was more lenient than he probably deserved: a fine of £250 to be paid to the king.

However, that was not the end of the issue. Public excitement was further aroused when a subsequent charge of a similar nature was brought against him. This time it involved the death of forty-eight year old Mrs Campbell Lloyd, wife of Captain Edward Lloyd of the Royal Navy. It was alleged that her death had been the result of the treatment she had experienced at the hands of St John Long. Long had to face yet another charge, this time at the Old Bailey on the 19 February 1831 but the jury returned a verdict of not guilty.

According to reports, several elegantly dressed ladies remained with the prisoner in the dock throughout the day, and to whom the verdict of not guilty appeared to give great satisfaction. *Bell's Weekly Messenger* (April 17, 1831) reported that a Mr Chubb, bookseller and publisher of Holywell Street, Strand, was served with a notice for a libel for publishing an account of the 'self-styled Mr John St John Long, the Harley Street Quack, Physician Extraordinary to several Ladies of Distinction, with whom his universal Success obtained for him the Appellation of the Female Destroyer. The trial is to come on in the Common Pleas, on Wednesday next...Mr Chubb intends to defend himself in person.'

Justice caught up with St John Long, because the cases ruined his career and he died at the age of thirty-six from tuberculosis. Long became the butt of derision. In 1835, the

satirical *Cruikshank's Comic Almanack*, writing on the death of Long, declared that the baton of charlatanry had now been passed to James Morison (another famous quack):

Tho' St John (I said) is gone, — that curer of all ills
We still have modest Morison's fam'd Vegatable Pills.

A satirical song appeared in *Valpurgis; or, the Devil's Festival* (1831) part of which went:

... ne'er yet was doctor applauded I song
Like that erudite Phoenix, the great Doctor Long
... The wretch, just expiring, springs healthy and strong
From his bed at one touch of the great Doctor Long
Great house-painting, sign painting, face painting sage!
Thou Raffaelle of physic! — thou pride of our age!

However, Long had a keen and loyal female following. His grateful patients erected a monument to him at Kensal Green Cemetery with the following inscription:

It is the fate of most men
To have many enemies and few friends
This monument pile
Is not intended to mark the career
But to show
How much its inhabitant was respected
By those who knew his worth
And the benefits
Derived from his medical discovery
He is now at rest
And far beyond the praises and censures
Of this world
Stranger, as you respect the receptacle of the dead
Read the name of John St John Long
Without comment

CHAPTER 16
Rape

The law on rape was always determined by the need to show that penetration had taken place. Clearly this made conviction difficult and, therefore, most men were charged for assault with intent to rape. If convicted then the rapist could face the death sentence. This was repealed in 1841 and was followed by a significant rise in successful prosecutions.

Thomas Williams, thirty-eight, was found guilty of raping Margaret Kew, a nine-year-old girl, in February 1835, six years prior to the repeal of the capital penalty. The incident took place in Marylebone and he was charged with 'unlawfully and feloniously and carnally' abusing her. Williams was sentenced to death.

CHAPTER 17
Riot

During the 1790s, the French Revolution had provided both the inspiration for radical demands and also alarmed the authorities that such a political upheaval might happen in England. London had already witnessed one of its most tumultuous disturbances in the Gordon Riots of 1780. Sir Francis Burdett (1770-1844) was a resident of Piccadilly after he had married into the Coutts banking family. By 1796, he became a Whig MP, with radical connections, and often raised issues such as parliamentary reform and the liberties of people — issues that marked him out as a thorn in the side of the House of Commons.

In 1794, he raised objection to the suspension of *Habeas Corpus* as part of Pitt's anti-revolutionary repression. In 1799, he forced an enquiry into the Cold Bath Fields prison where many radicals were held in overcrowded conditions. After he was re-elected for Middlesex in 1802, he was ousted on a technicality four years later. His speeches had endeared him to sections of the working classes, and in 1807 he was elected for Westminster. He continued to give his support to radical causes and later published, in William Cobbett's *Political Register*, a speech in which he had protested at the imprisonment of the radical Gale Jones, who had exposed a government cover-up over the Walcheren naval disaster in the Netherlands.

This provided the spark that led to a mass show of strength for Burdett but also provided something of a political turning point for him. On Thursday 5 April 1810, the House of Commons voted for his arrest on the grounds that it was illegal to publish parliamentary debates. The sergeant-at-arms attempted to enter Burdett's house but was refused, as Burdett rejected the legality of the warrant and appealed to the liberties of the Magna Carta.

News of the event quickly spread around the West End and thousands gathered at his house in support of him and his actions. The following day the mob threw stones at the windows of the Prime Minister in Downing Street, as well as those of prominent aristocrats and Tory supporters. The floodgates had opened, and on Saturday 7 April the Life Guards and other cavalry units were brought in to disperse the crowds by armed force. The crowds around Piccadilly and St James' appealed to householders to illuminate their windows in support and those that refused had their windows stoned. The newspapers predictably discredited the crowd as composing of pickpockets and idlers. The hated Lord Castlelraegh stupidly tried to merge with the crowd, but when he was recognized he disappeared very quickly for fear of his life.

More and more people came to strengthen the demonstration and joined in the pelting of the military. By Sunday, the crowd had barricaded Piccadilly but the sergeant-at-arms at last broke into Burdett's house, arrested him and took him to the Tower. In the melee several people had been killed and many wounded as the Horse Guards had trampled over many of the people. The Life Guards were despised for their actions and were referred to as the 'Piccadilly butchers'.

Burdett was released from the Tower without charge in June and a huge procession had gathered to welcome him. However, it was to be a disappointment as Burdett had decided to avoid his supporters by going to his house at Wimbledon. His friends who had come to escort him were incredulous as well as angry that Burdett should betray those had given him such fervent support.

The fiasco cost Burdett some of his support with the people who nicknamed him 'Sir Francis Sly-Go'. Nonetheless Burdett did continue voicing his radical views and returned to prison in 1820 for speaking out against the government's actions in the Peterloo Massacre in Manchester in August 1819.

The mob had certainly scared the wealthier sections of the West End in their mansions and the authorities, who had alerted 50,000 soldiers in anticipation of revolution. Two

Very little exists of Tyburn except a plaque in the road and Tyburn Way at Marble Arch.

years after the Piccadilly riots plans were made for the development of the area which saw the construction of a royal mile between Regent's Park and Carlton House. Regent Street, named after the Prince Regent, formed part of the plan prepared by John Nash and completed in 1825. It also provided a distinctive dividing line between the less respectable Soho and the more refined squares and streets of Mayfair.

THE OLD PRICE RIOTS

The theatre might be considered an unlikely place to associate with riots. However, in 1809 the new theatre at Covent Garden became the scene of rioting that lasted for three months. A year earlier, on 12 September 1808, *Macbeth* opened at Covent Garden, starring the great actress Mrs Sarah Siddons, but eight days later the theatre was destroyed by fire. The cost of constructing the new theatre had been so high that, when it reopened on 18

The riots at Covent Garden as caricatured by Isaac Robert Cruikshank, Killing No Murder as Performing at the Grand National Theatre.

September 1809, the management felt it had no option but to raise the price of admission from 6s to 7s for the boxes and from 3s 6d to 4s for the pit. Although the gallery price was unchanged it was of no consolation to the audience who could only see the legs of the performers. True, the cost incurred had been great, with damage estimated at £150,000 plus the loss of scenery, costumes and scripts.

Opening nights are often tense and full of anticipation, but this was an opening with a difference. As manager John Philip Kemble (1757-1823) stepped forward to introduce the production, he was greeted with a torrent of booing, whistling and shouts of 'Old prices Old prices', which continued throughout the performance of *Macbeth*. As the play came to its unceremonious end, the audience refused to leave. Mr Kemble, who would have been financially ruined, had it not been for a generous donation of £19,000 from the Duke of Cumberland, sent for the Bow Street police. Five hundred soldiers were dispatched to the gallery but the rioters climbed down to the lower galleries, and the action only served to make the situation worse, with the crowd not being dispersed until the early hours of the morning. Over the following nights, the inside of the theatre was covered with banners and slogans and magistrates appeared on stage to read the Riot Act. At one point, a coffin was carried in bearing the message 'Here lies the body of the new price, which died of the whooping cough on 23 September 1809, aged 6 days'. Kemble resorted to hiring the Jewish boxer Daniel Mendoza and his supporters in an attempt to quell the crowd. As with previous attempts at force, this also backfired and further antagonized the crowd.

The painter Joseph Farington noted in his diary the events of September 1809:

On Friday night, Sept. 22nd, at Covent Garden Theatre, where every preceeding night from Mond. Sept. 18th, there had been the most violent opposition to raising the prices, Mr. Kemble [the manager] came forward & told the audience that the Proprietors, in order to restore the public tranquility, were ready & desirous to submit the inspection of the state of their affairs to a Committee of Gentlemen of unimpeachable impartiality and Honour.

Although the riots continued for the next three months, little damage was done to the theatre. Kemble was finally obliged to accept the Old Price terms and to make a public apology from the stage which was greeted by loud applause and the hurling of hats.

CHAPTER 18
Scandal

There are many types of scandal, including political, religious, corporate, journalistic, celebrity, sporting and sexual. It is the latter which tends to generate most interest, especially if it is associated with one or more of the other types. Scandal is generally defined as a widely publicised incident, involving allegations of wrongdoing or disgrace. Such incidents are usually high profile and the reactions to them by the public are often contradictory. For example, a scandal can create enormous public interest as well as moral outrage.

Between 1800 and 1850 (not that this was any more exceptional than other period) there were many scandals that invited the wrath of both the press and the pubic. The greatest outrage was almost always associated with exposés of acts of sodomy. The accusation of sodomy was the most damning insult one could throw at an enemy. As the annual number of executions dropped during the first thirty years of the nineteenth century for all crimes, sodomy was the only crime for which the number of hangings remained more or less constant. Sodomy was historically known in England and Wales as buggery, and it was usually defined as the act of anal intercourse between two males or a male and a female. Buggery in England and Wales was made a felony by the Buggery Act in 1533 and the punishment for those convicted carried the death penalty until 1861. The lesser offence of 'attempted buggery' was punished by two years imprisonment or a spell in the pillory. In 1885, Parliament prohibited gross indecency between males, which meant most or all male homosexual acts. It was not until the Sexual Offences Act of 1967 that sexual acts between two adult males, with no other people present, were made legal in England and Wales.

THE VERE STREET COTERIE

Vere Street runs off Oxford Street, between the present Bond Street and Oxford Circus underground stations. In 1810, the so-called Vere Street Coterie, encapsulated, with a vengeance, the contemporary attitude towards homosexuality. Robert Holloway, a lawyer, published what was a combination of outrage and salacious detail of the event in 1813 in *The Phoenix of Sodomy, Or the Vere Street Coterie*. Holloway also offered his own view on homosexuality: 'the natural consequence of transactions which can only be produced

by a temporary insanity.' Those who were found guilty were subjected to the horrendous judgment of the mob whilst two others were executed.

The events unfolded when a 'Molly House', the White Swan (sometimes referred to as the Swan), Vere Street, was raided by Bow Street police on Sunday 8 July 1810 and twenty-three people, described as being of a 'most detestable description', were arrested including the landlord, James Cooke. Robert Holloway described the White Swan as having four beds in one room. A second room was furnished in the style of a ladies' dressing room, with a toilette (toilet). Another room was called the Chapel because 'mock marriages' took place here (more of this later). Upstairs was given over to young men who waited for customers. Many of these customers were men from respectable society and of high rank who were more than happy to mix sexually with those of a lower class. Assumed names were adopted by those who visited the White Swan, such as Black-eyed Leonora, Pretty Harriet, Miss Sweet Lips, Lady Godiva, Duchess of Gloucester and Duchess of Devonshire.

News of the raid spread quickly and very soon a mob of people began to congregate around Bow Street where the accused had been taken. The arrested men included Esau Haycock, shopkeeper, near the Yorkshire Stingo public house, New Road, Marylebone; James Amos, alias Fox, lodger at the White Swan, a servant and disabled in the arm; William Thompson, waiter at a hotel in Covent-garden; Henry Toogood, servant to a gentleman in Portland-Place; Robert Aspinall, tailor and lodger at Brewer's Court; Richard Francis, a corporal in the Third Regiment of Foot Guards; James Cooke, landlord of the house, and Philip Hot, the waiter. In total, twenty-seven men were arrested but in the end the majority of them were released and only eight were tried and convicted. One reason why many were released was a lack of evidence, another was the possibility of bribes. The men had to face the hostility of the crowd who kicked, punched and threw mud at them as they tried to leave the police station.

On 22 September, Amos (alias Fox), James Cooke, Philip Ilett, William Thompson, Richard Francis, James Done and Robert Aspinal were indicted for conspiring together at the White Swan, 'for the purpose or exciting each others to commit a detestable offence'.

Witnesses included two policemen, who had infiltrated the house for three nights, observed the activities and given information about all they had seen. According to the court, what they witnessed would have excited 'an idea that the horrors of Sodom and Gomorrah were revived in London'. John Cooke, the landlord, who was not involved in the activities of the coterie, commented that many of the respectable would stay several days at the house and amuse themselves with upwards of a dozen different boys and men.

Over the course of the following week, six of the convicted men who were found guilty of attempted sodomy were pilloried in the Haymarket. Amos was sentenced to three years' imprisonment and to stand once in the pillory. Cooke, Ilett, Thompson, Francis and

Done were each sentenced to two years' imprisonment and the pillory, and Aspinal was sentenced to one year's imprisonment.

The Times reported that the concourse of people that turned out 'was immense ... even the tops of the houses in the Haymarket were covered with spectators'. It was estimated that there were about 40,000 people gathered. It was also a very violent and unruly crowd who had to come to vent their anger equipped with various objects to throw. The article noted that the women were particularly vicious. So large were the mob that the City had to provide a guard of 200 armed constables, half of whom were mounted and half on foot, to protect the men from even worse mistreatment.

The men were conveyed from Newgate to the Haymarket in an open cart. It did not help their cause, as Amos began to laugh, which prompted his companions to reproach him. They all sat upright but could not help but look on in fear and dread as they saw the sight of the spectators on the tops of the houses ready to hurl verbal and physical abuse. About sixty officers, armed and mounted, along with the city marshals, rode ahead of the cart. Then, from the crowd, followed a cacophony of hisses, boos, hooting and execration accompanied by a volley of mud which made the men to fall flat on their faces in the cart.

The mob formed a gauntlet along Ludgate Hill, Fleet Street, the Strand and Charing Cross, and they lost no time in pelting the men with their assortment of projectiles. The condemned eventually arrived at the Haymarket at one o'clock in the afternoon, ready to face yet another bombardment. However, the pillory would only accommodate four, so two men were taken to St Martin's Watch-house to wait their turn. Once a space was formed around the pillory a number of women were admitted to commence the proceedings. With great vigour they rained down a shower of dead cats, rotten eggs, potatoes and buckets filled with blood, offal and dung, which had been brought by butchers' men from St James' Market. During the next hour of agony the men walked constantly round the pillory, which was on a fixed axis and swivelled.

The two remaining prisoners, Amos and Cooke, were then placed in the pillory and were also pelted till it was scarcely possible to recognize a human shape. Cooke was almost knocked insensible and was helped back into the cart. The cart then conveyed them through the Strand and to Newgate, the mob continuing to pelt them all the way. As they passed Catherine Street, a coachman stood and gave Cooke six cuts with his whip. The men could not lie down and shelter themselves because the chains prevented them from doing so. By the time they reached Newgate some of them were cut in the head and bled profusely.

The Morning Chronicle reported the events in the following way:

The horrible exhibition of yesterday must prove to every considerate spectator the necessity for an immediate alteration in the law as to the punishment of this crime. It is obvious that mere exposure in the pillory is insufficient; to beings so degraded the

pillory of itself would be trifling; it is the popular indignation alone which they dread: and yet it is horrible to accustom the people to take the vengeance of justice into their own hands.

The paper went on to blame foreigners for such a crime committed by the prisoners:

We avoid entering into the discussion of a crime so horrible to the nature of Englishmen, the prevalence of which we fear we must ascribe, among other calamities, to the unnecessary war in which we have been so long involved. It is not merely the favour which has been shown to foreigners, to foreign servants, to foreign troops, but the sending our own troops to associate with foreigners, that may truly be regarded as the source of the evil.

Two men, forty-two-year-old John Newbold Hepburn, formerly an officer in a West India regiment and eighteen-year-old Thomas White, a drummer boy, were convicted of the act of sodomy despite not being present at the White Swan during the night of the raid. They were indicted at the Old Bailey in December 1810 for 'perpetrating with each other a detestable crime, at Vere Street' on 17 May. *The Times* recorded that the 'two delinquents were apprehended, shortly after the discovery of the detestable society in Vere Street,

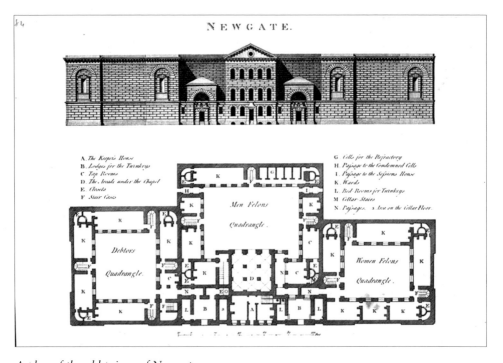

A plan of the old prison of Newgate.

upon the accusation of a drummer, named James Mann, belonging to the 3d Regiment of Guards.' Mann had stated that Hepburn had accosted him on the Parade in St James' Park a few days before the day on which the offence was committed. Hepburn had told him that he was very anxious to speak to the boy, White, and said he would reward him if he would bring the lad to his lodgings at St Martin's churchyard. That evening Mann and White went to Hepburn's lodgings, and there they proposed that they should meet the following Sunday at the Swan, Vere Street. When they met at the Swan they went to a private room, where they dined and then committed 'the most vile and disgusting' act'. White was a particular favourite at the club and was said to be 'very deep in the secrets of the fashionable part of the coterie'.

Hepburn and White received the death sentence and were executed at Newgate on 7 March 1811. At the usual time for executions, eight o'clock in the morning, Hepburn and White mounted the scaffold in front of the debtors' door of Newgate. White came out first, adjusting his shirt whilst looking at the crowd that had gathered, and two minutes later he was followed by Hepburn. They behaved with great dignity as the executioner placed a black hood over their heads. After some minutes in prayer they were hanged before a vast crowd of spectators. The mother of Thomas White was so distraught she never left her bed and eventually died, it was said, of a broken heart.

Vere Street Part 2: The Revd John Church

In his autobiography *The Foundling; or the Child of Providence*, John Church (1782-1835) compared himself with, among others, Moses, John the Baptist, Samson and, of course, Jesus Christ. It is a useful starting point as it tells us something about his immodesty. Church became famous for his involvement in the Vere Street Coterie and for performing mock marriages between men. However, he denied his connection with Vere Street, claiming that it was propaganda by his clerical opponents, and he took legal action.

He was a foundling discovered on the steps of St John's church, Clerkenwell (hence his name). He was sent to the Foundling Hospital where he received a basic education. In his late teens he joined the Baptist Society, the Expounding Society and the Westminster Itinerant Society of Dissenting Ministers. Church married a Miss Elliot in 1801 at the Swedenborgian New Church in the Strand. It was not long after that Church fell in love with William Webster, who he met at Tottenham Court Road chapel (*Who's Who in Gay and Lesbian History*, Robert Aldrich and Garry Wotherspoon, 2002).

Church took a living as a parish minister in Banbury, but this ended in 1808 amid rumours that he had been 'sodomitically assaulting' several 'young buckish men' whom he would observe as they bathed in the local pond. It no longer became healthy for Church to stay in Banbury, especially when the word 'sodomites' was scrawled on the wall of his meeting-hall.

He moved to London, and it was in his next living that he became most associated as a preacher. This was the Obelisk chapel, St George's Field, south London, a post that he held between 1810 and 1820. It was also in 1810 that he asked to become chaplain at the White Swan molly house in Vere Street, where he famously carried out the mock marriages of up to four male couples at a time in a room known as the Chapel.

He was fortunate not to be among those arrested in the raid in 1810. However, he was later exposed by James Cooke, the landlord of the White Swan, as well as the press. Both revealed details of Church's relationship with Webster ten years earlier. Cooke denounced Church in *Hypocrisy and Pollution; An Account of the Life and Character of John Church the Obelsik Preacher*. Although the title was much longer, Cooke added to that title, just in case people might have not made the connection, *Formerly a Frequenter of Vere Street and who has been charged with Unnatural Practices*. These, and the revelations of the *Weekly Dispatch*, provoked mobs to attack his Obelisk Chapel, and his notoriety was further highlighted when his activities became the object of over 20,000 pamphlets, books and broadsheets. Matthew Parris, in his book *The Great Unfrocked* (1998), records how one day in 1813 Church was walking down Blackfriars Road when he passed a bookseller's window stocked with pamphlets containing the Vere Street incident. 'Soon after on every corner of the streets and every lamp-post had a placard posted with these elegant words, in capital letters, JOHN CHURCH, INCARNATE DEVIL.'

Despite this, Church was not prosecuted and the publicity ensured that his services would be packed out. His congregation doubled and huge crowds assembled outside his Obelisk Chapel.

1813 proved to be quite a year for Church, as his wife, who had born him four children, died of drink. Church remarried and three years later, in 1817, he was convicted of sodomy and imprisoned for two years. The accusation came from nineteen-year-old Adam Foreman, an apprentice potter, who told how Church had woken him in the night by putting his hand under the bed clothes and holding his genitals, and feigning his mistress' voice.

After the verdict a large crowd burned an effigy of Church outside the Obelisk chapel. According to his autobiography, published in 1823, Church served his time in Newington and Horsemonger Lane jails in great anguish. He put his time to good use by writing sermons and was well catered for by his many female admirers, who brought him drink and food. On his release he continued to preach to packed congregations, but after 1824 no more is known of him.

THE BISHOP AND THE GUARDSMAN

In the back room of the White Lion Tavern, St Albans Place, off the Haymarket on the evening of 19 July 1822, a huge scandal occurred. It was such a scandal that in the days

that followed 'it was not safe for a bishop to show himself in the streets of London', said Charles Manners-Sutton, who was Archbishop of Canterbury at the time. For 178 years afterwards the Church of Ireland refused to let historians see their papers regarding the incident. 'Never were the laws of God or man more outraged — British feeling more insulted — human nature more degraded', stormed a contemporary account. The scandal that shocked the church and respectable sections of society also found a public clamouring to read as much as they could about it. In his book *The Great Unfrocked* (1998) Matthew Parris recalled attempting to gain access to the records: 'When at the beginning of 1998 I requested to see them, it required the personal decision of a more enlightened Primate of All Ireland, Archbishop Eames, finally to authorize their release.'

The shocking revelation concerned Percy Jocelyn (1764-1843), Anglican bishop of Clogher in the Church of Ireland from 1820-1822. He was caught literally with his breeches round his ankles, in full Episcopal garb, with a young guardsman, John Moverley, who was dressed in full uniform.

Jocelyn was the third son of Robert Jocelyn, first Earl of Roden. Percy was described as being six feet tall, 'powdered hair, stout, sallow complexion, pointed nose, dark eye, having something of the appearance of the foreigner, but of reverend appearance.'

The background to what became the embarrassing event at the White Lion had started when Jocelyn had made an arrangement to meet Moverley. Once the bishop had finished his stint in the House of Lords both men went into the tavern. Suspicions were soon aroused as the two men furtively crept into a room in the pub. This awakened the curiosity of the landlord's son-in-law, who quickly followed and peered through the window at the bishop and the soldier. What he saw led him to go scurrying off to tell the landlord, who in turn informed the local watchman. Before long an audience of eight had gathered to look through the window; one can only guess at their whisperings. After a while they decided they had seen enough and burst into the room at the critical moment when the soldier was about to consummate the act with the bishop.

In the second volume of the four-volume *Sexual Outcasts, 1750-1850* (2000), Ian McCormick offers various contemporary accounts of the incident. On being discovered Jocelyn declared, 'what have I done? Nobody has seen any thing, nobody can hurt me!' When it was revealed to him that a sufficient number of witnesses had seen everything, his tone changed and he exclaimed, 'Oh God! God should I come to this? I'm undone.' He certainly was, and in more ways than he imagined! He then resorted to pleading, asking the witnesses to let him go. No sympathy was shown.

Jocelyn, in his bishop's garb, tried desperately to escape but was hampered by his breeches wrapped around his ankles. Both men were taken to nearby Vine Street watch-house where they were met with the wrath and mocking of the crowd.

One account of the incident, which rather agonized that it was their 'painful and disgusting task' to relay such information, went on to give salacious details of the events:

A Bishop of the Established Religion dragged through the public streets (almost in a state of nudity) like a felon with a common soldier as his companion in iniquity, followed by the execration of the mob, whose numbers increased on the way to the watchhouse and the crime of ---- laid charge to the parties, which was vociferated in every direction.

The paper, as with many others who reported the event, could not utter the name of the crime of sodomy. One newspaper reported, 'the extreme interest excited on this occasion is wonderful; the mere appearance of a clergyman in the streets of our metropolis causes him to be pointed out and laughed at …' Jocelyn made a pathetic attempt to escape but he was quickly brought back to order. By now he was sporting a few cuts and bruises from the crowd, who added to the indignity of it all by ripping his clothes.

After a night which must have contained much prayer and begging for forgiveness the men were taken the next morning to Marlborough Street magistrates court. As they heard the charge they both wept. Jocelyn's prayers must have been at least partly heard, as he was not charged with sodomy because there was no evidence of penetration. Instead, he was charged with committing a misdemeanour. He was released on bail, which had been provided by the Earl of Roden and others, whilst the unfortunate Moverley stayed in prison because he could not raise the bail. When Jocelyn left he had to face, yet again, the protests and insults from an angry crowd.

News of the incident spread rapidly around the taverns and streets, and soon became the subject of satire and popular ribaldry, resulting in more than a dozen illustrated satirical cartoons, pamphlets and reports in the press. One particular Limerick went:

The Devil to prove the Church was a farce
Went out to fish for a Bugger.
He baited his hook with a Soldier's arse
And pulled up the Bishop of Clogher.

The government was particularly sensitive towards the incident, because it not only embarrassed the Church of England but also, as Matthew Parris points out, Lord Castlereagh, the Foreign Secretary, who was being blackmailed over a similar scandal. He too had been implicated with a soldier and had been caught despite his appeals that he thought the soldier was a woman. For Castlereagh it was the final straw and, in a fit of desperation, he committed suicide by cutting his throat. According to the law regarding suicide he should have been buried at a crossroads with all the indignity that went with such a ritual. However, there are always exceptions to the rule, particularly when it came to such a leading member of the establishment as Castlereagh. It was declared that he had been under such 'a grievous disease of mind' that such a 'state of mental delusion in manner' led him to 'kill and destroy himself'. Lord Byron's epitaph summed up the hatred towards Castlereagh:

Posterity will ne'er survey
A nobler grave than this:
Here lie the bones of Castlereagh:
Stop, traveller and piss

Jocelyn jumped his bail, fled the country and eventually went to live in Scotland where he worked as a butler. In December 1824, at a service at Marylebone church, Jocelyn was officially declared to be an outlaw. In December 1843, he died in Edinburgh, in privacy, and some would say obscurity, under the name of Thomas Wilson. The Latin inscription on his coffin plate reads, 'Here lie the remains of a great sinner, saved by grace, whose hopes rest in the atoning sacrifice of the Lord Jesus Christ.' To add to the intrigue, it was reputed that the Jocelyn family vault at Kilcoo parish church in Bryansford, County Down, Northern Ireland, was opened and there was one coffin more than the number of grave markers indicated. This raised speculation about whether it was that of Percy Jocelyn. As for Moverley, the Establishment once again showed its ability to minimize embarrassment to one its institutions by discreetly getting him out of the country with nothing more heard of him again.

The case has raised all sorts of issues, particularly in relation to the inconsistency of the punishment. When others had been severely punished for the same crime Jocelyn seemed to have been let off lightly. This matter was raised through letters to the papers. The same may be said with regard to Castlereagh's death. Why did he have a state funeral whilst other suicide victims suffered an ignominious burial? According to William Cobbett in *Rural Rides* (1830), had the Jocelyn incident been committed during the time of the French Revolution there would have been a very different sensitivity:

To say, or hint, against a parson, do what he would, was an enemy of God and of all property. I believe that if he [Percy Jocelyn] and ... John Moverley ... had committed their horrid crime in the time of Pitt or Perceval, or before low prices came, no man would have dared to say a word about it; and that if any man had dared to say a word about it they would have been hunted down as an atheist or a Jacobin.

We can only speculate at what might have happened had Jocelyn not jumped bail. At least he had that option which he used as a green light to get away. Many others did not have that opportunity. Was it a case of different times, different circumstances or one law for some and not for others? It seems the latter has had a remarkable continuity and consistency.

'Lewd act' in Hyde Park

The Times (15 February 1843) was horrified to report that a respectably-dressed, gray-haired, elderly person, who happened to be a wealthy baronet, was charged along with George Stacey, butler, for 'indecently exposing and behaving themselves in Hyde Park'. The two men were watched while they hid themselves behind a tree and 'acted towards each other'. Once this activity was over, the men looked around to see whether they had been observed, and all of a sudden the witness, his brother and a constable pounced upon them, finding Stacey and the butler with 'their trousers unbuttoned'.

Publish and be Damned

The scandalous memoirs of Harriette Wilson, a Mayfair prostitute, who tried to blackmail the Duke of Wellington, had everything that modern tabloids would love: kiss and tell, scandal, blackmail and the exposure of people in high places. In the 1820s, such was the insatiable demand for her memoirs that people queued ten deep to read them.

Harriette Wilson (*c.* 1786-1845) was one of fifteen children to Amelia and John James Dubouchet, a Swiss clockmaker who kept a shop in Mayfair and who adopted the name Wilson around 1801. At fifteen years of age, Harriette embarked on her chosen career. Her conquests read like a *Who's Who* of the great and not so good. These included (allegedly) the Prince of Wales, the Lord Chancellor (Henry Brougham), at least three future Prime Ministers (Duke of Wellington, George Canning and Lord Palmerston) and various earls, viscounts and lords. Her sisters, Amy, Fanny and Sophia, also became courtesans. At the beginning of her memoirs Harriette attempted to explain why she had chosen this way of life:

> I shall not say why and how I became, at the age of fifteen, the mistress of the Earl of Craven. Whether it was love, or the severity of my father, the depravity of my own heart, or the winning arts of the noble lord, which induced me to leave my paternal roof, and place myself under his protection, does not much signify; or if it does, I am not in the humour to gratify curiosity in this manner.

She was not a particularly beautiful young woman but she was smart and sufficiently saucy to make the most she could from her entry into London Society. She would often be seen in fashionable Mayfair circles and in her opera box or carriage. After taking a number of lovers she caught the attention of the Earl of Craven before moving on to the Duke of Argyll, the third Duke of Leinster and the Marquess of Worcester (who paid her £1,200 to end the affair). The one man who Harriette fell deeply in love with was Lord John Ponsonby (who was, inconveniently, married). However, he left her and became

involved with her younger sister, fourteen-year-old Fanny. As for Harriette, her taste for rich men knew no bounds.

By 1826, she hit forty and was losing her physical appeal as well as her lucrative sources of income. One way of securing and financing the lifestyle to which she had become accustomed was to write a kiss and tell memoir. This genre has a long, and sometimes fraught, history (see *Whore Biographies, 1700-1825*, in eight volumes, 2006-2007, edited by Julie Peakman). Clearly there were many clients who started sweating at the prospect of Harriette's promised exposés.

There was also another potentially profitable side to the memoirs and that was her threat to reveal the amorous adventures of those in high places. In other words, blackmail. Mary Ann Clarke, another courtesan, had squeezed £10,000 out of the Duke of York in order not to publish her memoirs. This idea was attractive, and it is at this point that her publisher, John Joseph Stockdale, appeared on the scene.

Stockdale (1770-1847) was a publisher and editor who kept a bookshop off Charles Street near Haymarket. Educated at a private school in Bedfordshire, he worked in the publishing trade and married, in 1805, Sophia, niece of Philip Box, a banker. It was Box who gave Stockdale financial help to set up his business, where he compiled and edited many books, some of which gained the reputation of being rather salacious in their illustrations. However, it was his publication of the *Memoirs of Harriette Wilson* (1826) for which he became most well known.

Before the memoir was published Stockdale and Wilson decided they would write to all the clients mentioned in the book, offering them the opportunity to be excluded on condition they made a cash payment. They wrote to about 200 men, demanding the sum of £20 per year or a lump sum of £200 in order to keep quiet about their dalliances. This was blackmail on a very grand scale. When the Duke of Wellington received his letter he famously retorted with 'Publish and be Damned'. However, as with many so-called famous quotes throughout history, there is no direct evidence of him actually saying this.

True to their word, they published the *Memoirs of Harriette Wilson* with the inclusion of Wellington's activities. Harriette's memoirs were published in nine paper-covered installments between February and August 1825 and became an instant best seller. An excited public flocked to the Haymarket to get their copies, and barricades had to be erected to keep the avid crowds in order. Stockdale had promoted the book by offering a taster of what was inside when he advertised a list of those names who would be appearing. Such a ploy allowed Wilson's readers to follow the intimate developments as well as whetting appetites for the next installment. The newspapers quickly realized the potential that such sensational tales had for their sales and they soon joined in.

The memoirs certainly implicated many eminent people in the establishment and there were those who coughed up, including the cowardly George IV, who, four years later on his deathbed, cursed 'Harriette Wilson and her hellish gang'. Wilson said of those that refused to pay that she 'never attempted to expose them, till all my civil, humble,

and abject prayers and protestations had failed to wring from their impenetrable hearts one single paltry hundred a year.' Earl Spencer offered to buy the entire manuscript for £1,000.

By modern standards there is nothing that is sexually explicit in the memoirs. They were very much in the form of 'nod, nod, wink, wink' and a good deal of suggestive and embellished remarks. The *Memoirs of Harriette Wilson* has its funny moments, with anecdotes about men such as the Duke of Wellington, whom she described as looking like a rat catcher and included an illustration to demonstrate the point. She wrote of how Lord Craven bored her, wore a moth-eaten nightcap and droned on about his cocoa trees in the West Indies when he should have been making love to her. Nonetheless, she took Wellington at his (alleged) threat of 'Publish and be damned'. She did and she was.

She may have profited from what she received from blackmail but less so with the book as the many pirated copies that 'sexed up' parts of the *Memoirs of Harriette Wilson* probably did better sales. Not long after the publication Harriette went to live in Paris with her husband, William Henry Rochfort, who had already left to escape the wrath of his creditors. Although she turned her hand to writing fiction, for which she had gained much experience, this failed and she returned to her old profession but this time as a

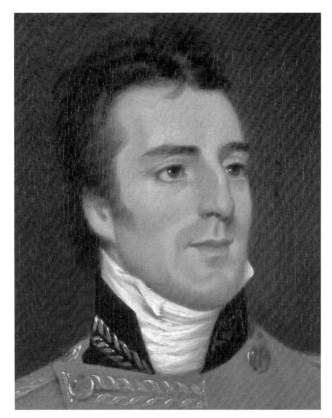

The Duke of Wellington, who reputedly said, 'Publish and be damned' when faced with threats of blackmail from Harriette Wilson.

Harriette Wilson.

procuress of young women. Her husband deserted her, as did her old society friends, and she was reduced to sending out what amounted to begging letters to old lovers. She died in poverty in 1846. Harriette's long relationship with Henry Brougham continued after he became Lord Chancellor, and it was Brougham who organised the payment for her funeral.

As for Stockdale, he became embroiled in libel suits. The HM prisons inspectors discovered in 1839 that a well-thumbed copy of his edited book, *On Diseases of the Generative System*, had been doing the rounds in Newgate Prison (an unusual, but no doubt popular, read for the prisoners of Newgate). It was less the written content than the illustrations that Stockdale had added that made the book more 'appealing', and this had created the flurry of interest. The images were thought to be pornographic by the standards of the day. The *Report of the Inspectors of Prisons* stated that indecent material had been circulating at Newgate and this information was, by order of the House of Commons, published in *Hansard*. Stockdale sued for defamation, which led to an important constitutional clash between Parliament and the courts over the issue of parliamentary privilege. This was only resolved when the Parliamentary Papers Act, 1840, was introduced, enacting that proceedings, criminal or civil, against persons for the

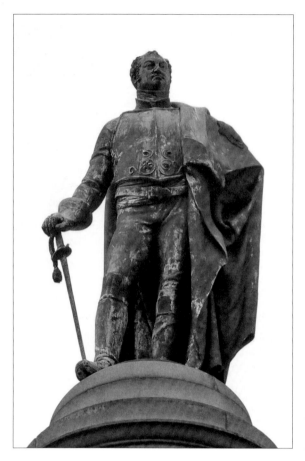

Statue of Frederick Duke of York, 1763-1827, second son of George III, in Waterloo Place.

publication of papers printed by order of either House of Parliament should be stayed (halting further legal process in a trial). Stockdale was defeated and died a year after Harriette Wilson.

His wife continued in her attempts to blackmail Henry Brougham but with little success. The ruling powers had, after some embarrassing moments, come through yet another scandal relatively unscathed.

THE GRAND OLD DUKE OF YORK AND HIS MISTRESS

Gloucester Place in Marylebone also established a reputation as the area where the mistresses of the rich and famous lived. Many were kept and indulged in an extravagant lifestyle. One of the most well known was Mary Anne Clarke (1776-1852), the daughter of a bricklayer.

Clarke lived with all the trappings of a pampered courtesan, owning ten horses, many

carriages, twenty servants, three cooks and an additional house at Weybridge. From 1802 to 1809 she was the mistress of Frederick ('The Grand Old') Duke of York, Georges III's son. The Duke had set Mrs Clarke up with the generous sum of £1,000 a year. His letters expressed his absolute desire to be with her:

My Dear Mary Anne
I am engaged this evening to play at whist with Old Snuffy: the moment I can escape from the set I will fly to the dear embraces of my beloved darling.

In 1809, a national scandal arose when the Duke was charged with corruption for promoting officers from whom Clarke had taken bribes. The Duke was pressured to leave Clarke, which he did by giving her a reduced pension of £400. This clearly displeased her, and she proved to be quite resilient in her reaction by writing her revealing memoirs and extracting huge pensions from the government to keep the details suppressed. The Duke was forced to resign from his position. However, he was later cleared and reappointed, and he remained in office until his death in 1827. Anne Clarke was later prosecuted for libel in 1813 and subsequently imprisoned. On her release, she went to live in France.

CHAPTER 19
Theft

Theft has always been the most common crime and punishments varied from the lenient to the extremely brutal. Distinctions were dependent on the value of the goods being stolen, as well as the way in which the theft took place. For example, there was a distinction between burglary and housebreaking. Burglary was breaking into a house at night whilst housebreaking took place in the day and included other buildings such as shops or warehouses. Up to 1827, the two main categories of theft were grand larceny and petty larceny. Both grand and petty larceny were replaced by the new offence of simple larceny in 1827. This new category covered all types of theft without aggravated circumstances, such as assault or theft from the person or a specified place.

Other types of theft included pickpocketing, which, until 1808, meant stealing from another person goods worth more than 1s. After this date the definition covered any theft from the person and the death penalty no longer applied to this offence. Shoplifting, as the term implies, meant stealing goods from a shop worth more than 5s. Up until 1823, this offence carried the death penalty. In the same year, the offence of 'Stealing from a Master' was created. This applied to servants who stole from their employer, or master. The more serious punishments were handed out to anyone found guilty of robbery with violence. Highway robbery had been common before the nineteenth century but with improvements in roads and policing these activities declined, with the last case being heard in 1830 at the Old Bailey.

Because cases of theft were so common many have been summarized below in order to show the diversity of the crime and the punishments that accompanied them. Nonetheless, there are abundant examples that vary from the sad to the ridiculous.

The area of Piccadilly has been a magnet for pickpockets, conmen and thieves for decades. In August 1800, fourteen-year-old William Shattock was sentenced to seven years' transportation for stealing a pair of stockings from Walter Fitzgerald. Two months later Robert Classon, twenty-five, was sentenced to death for breaking into a house in Jermyn Street and stealing two silver teaspoons. He was chased along Windmill Street before being caught. The following year yet another of the Shattock family appeared before the court charged with stealing a brass lamp, powder-box, a tin oil bottle, an iron stand, a snuffer a dozen knives and forks, and 'a great variety of other articles' from offices in Great Windmill Street. He too was sentenced to seven years' transportation.

At the other end of the age range, John Mason and James Spraggs, who were both in their sixties, were transported for seven years each for stealing a promissory note.

Petty Crime, Harsh Punishment

The case of Thomas Ford was a trivial one. He was charged with stealing eleven pounds of flour and two loaves on 29 December 1809. How long Ford had been stealing from the same bakehouse is unknown. His employer suspected him so called an officer. Hoping to catch him in the act, the employer cut a hole in the bakehouse door to watch Ford as he poured two shovels of flour into a handkerchief then placed this in his hat. It can hardly be called the crime of the century but it carried a sentence of seven years' transportation, which the twenty-eight-year-old Ford received.

Similarly, two teenage girls, Jane Smith and Ann Riley, stole 7s worth of goods from a shop in Oxford Street and were transported for seven years each. Ann Riley left a few months after her conviction on the female convict ship from London, HMS *Mary III*.

Lucky Find, Unlucky Loss

Bell's Weekly Messenger (May 16, 1830) reported that a Jewish boy went to the mansion of Prince Esterhazy, Chandos Street, near Cavendish Square, and offered to sell some earthenware. One of the servants dealt with him and eventually bartered with the boy some old shoes in exchange for two earthen cups of small value, and the boy went away.

However, it had so happened that a few days before one of the male servants had sold some stock from the house to the amount of £30. On his return home he, for security, foolishly crammed them into the toe of one of the old shoes and placed it amongst the rest. His fellow servant was ignorant of this fact and gave the boy the one containing the treasure in it! The owner was, to say the least, upset, and he offered a reward for the recovery of the property. Whether the money was returned we do not know, but the boy must have thought that was one of the best exchanges he had made — unless of course he never discovered the money.

A Hiding to Nothing?

Harriett Haynes was sentenced to be whipped in prison for a 'violent' theft on twenty-year-old Samuel Harris and for 'putting him in fear'. Late one night on 25 January 1805 Harris was walking through Soho Square when Haynes approached and put her hands in his waistcoat pocket. Many might not have interpreted this action differently, but Harris said he was in a hurry and afraid he might be locked out of his lodgings so he asked Haynes to let him pass. All this fumbling in the dark led Harris to accuse her of stealing money from him, which she denied.

This was a case of his word against hers, but Harriet finished up getting a flogging before being discharged.

OUT FOR A DUCK

Animal theft was common and usually involved the stealing of sheep, cattle, horses, pigs, and fowl. In the eighteenth century, horse, sheep and cattle theft were capital offences. Whilst most times of the year were ripe for stealing animals, Christmas had a particular attraction for the theft of poultry.

In 1825, Robert Parmington, twenty-one, and John Smith, nineteen, received a public flogging for stealing three ducks. John Winsor kept poultry and complained about the disappearance of ducks at Christmas time. A man who passed his shop informed him that he had seen two young men at the corner of Regent Street with a suspicious looking bag. Winsor set off in quick pursuit and managed to catch the young men and recovered his two ducks and a drake.

The defence that was offered stretched the imagination. Smith said, '[I] found the bag … I was going to a chandler's shop to enquire whose it was when I was taken'.

Public whippings usually entailed the guilty person stripping to the waist and being flogged at a cart's tail along a street, often near to where the crime took place. Both men and women received the punishment until their backs were 'bloody'. Private whippings usually took place inside the prison. Parmington and Smith received their punishment at a time when public floggings were in decline, and, in fact, they ended in 1830 (1817 for women). Private floggings continued until 1948.

A VEILED THEFT

John Hammond, who lived in Burlington Mews, Regent Street, should probably have been a little more careful when he brought home Esther Murrell, thirty-two, on 14 September 1827. That evening they had visited several pubs and she was well plied with gin. Hammond took her to his house and then to his bed. When he woke around two to three in the morning Esther had gone and so had two coats, a waistcoat, a shirt, two handkerchiefs and a snuffbox. All very embarrassing for Hammond, particularly his inability to recognise the woman. She was wearing a veil that evening when they went out on their drinking session, but Hammond had no candle in his room so he was denied seeing her before they got into bed. Clearly, she must have had other charms that Hammond was attracted to.

A watchman arrested Esther as she was making her way along Regent Street complete with her booty. At least Hammond recognized his belongings. Esther protested that Hammond had not only given her too much to drink but had also told her to take the belongings. She was sentenced to seven years' transportation.

Pleas for Mercy

(1) By the Court

James Jordan, thirteen; William Donald, twelve; and Thomas Steers, thirteen, were sentenced to death in 1821 for stealing six silver spoons from a house in William Street, Manchester Square. They were almost caught in the act when a neighbour saw them and gave chase. He knocked Donald over and then followed Jordan, who threw the spoons into the cellar of the Jacob's Well public house in Charlotte Street. The spoons were soon retrieved and the boys were arrested on Oxford Street.

Each of the boys were sentenced to be executed at Newgate but were recommended to mercy on account of their age.

(2) By the Culprit

Fourteen-year-old James Anderson was transported for seven years for breaking into the house of spinsters Maria and Harriet Heim in Golden Square, Soho, in November 1807. The women, who kept a haberdashers shop, saw Anderson stealing goods and, with the help of some workmen, secured him until the police came. The boy fell to his knees and pleaded with his captors to forgive him and let him go.

An Opportunist

Mary Crooks was found guilty of stealing from a house in Oxford Street in 1807. Crooks, an opportunist, went to the house to give help with a kitchen chimney that was on fire, but she left with someone's purse, which had been left on the stairs, containing five £1 notes and a bill of exchange for £42 and 15s. When asked in court what she had done with the money she replied that she had 'got drunk and lost [it]'. Despite calling three witnesses to give her a good character reference, twenty-six-year-old Mary Crooks was given the death sentence. However the jury recommended her for mercy because of her good character, this being her first offence and the fact that her husband had driven her to distress.

Stealing a Letter with Money

Many people today have experienced the loss of a letter or package in the post. It is even more infuriating when it contains something of value. The penalty for stealing mail in 1811 carried with it a very serious punishment, as Daniel Davis found to his deep regret.

Davis was a letter-carrier for the general post office. William Scolfield of Liverpool had trusted the mail to deliver his letter containing £10 to his father, who lived at King Street, Covent Garden, when he posted it on 29 May 1811. Two days later, the letter had still

not arrived, so William Scolfield went to the bank and stopped payment of the note. By 31 July a publican, William Rose, who kept the Crown and Two Chairmen in Dean Street, Soho, paid the same note into his bank. When asked where he had got the money from, Rose said he received it from the letter-carrier, whose name he had written on the note.

It did not take long to locate Davis who, for his pilfering, received the death sentence.

No Second Chance

Between 1787 and 1868 over 160,000 convicts were transported, mainly to the east coast of Australia. Before prisoners set sail on the convict ships they were held in prisons, many on the hulks — old warships moored on the Thames. Some prisoners managed to escape from these. Twenty-eight-year-old Samuel Beach was charged in July 1802 for breaking into the house of a George Skillicorn. He stole 'several articles, 720 pieces of copper, goods, chattels, and monies.' Initially he was given the death sentence but this was transmuted to transportation. He was delivered on board the hulks at Woolwich in February 1803.

A few months later Beach was seen as large as life walking along Bond Street, where he was recognised and apprehended. In his defence Beach had nothing to say, adding that 'a man in my situation would do anything to get away; I had not done any thing amiss when they took me.'

He did not get a second chance and this time was sentenced to death.

A satirical print depicting convicts setting sail for Botany Bay.

An Expensive Afternoon's Work

William Penny, twenty-one, paid a heavy price for one afternoon of picking pockets. A royal procession was taking place in Piccadilly in October 1820 and, predictably, a large crowd had gathered, which meant then there would be good pickings. As Penny circulated among the crowd he helped himself to a watch valued at 20s, a piece of ribbon and a key from Richard Cornelius. Penny, like many pickpockets, worked in a gang who would help each other. When Cornelius saw Penny's hand moving away from his pocket with his watch he grabbed hold of him. Within seconds some twenty to thirty of Penny's partners in crime rushed to his aid. The activity alerted the police who then ploughed into the gang and before long a general fracas had broken out. Nonetheless, Penny, who, whilst holding some of the stolen items, said he knew nothing of it, was arrested. For his afternoon's efforts he was transported for life.

Highway robbery has a tendency to conjure up images of a romantic masked 'gentleman of the road' holding up a coach then politely leaving having thanked the victims. This is a myth created by popular fiction and the reality was that the highway robber was usually a nasty thug. Highway robbery was defined as theft that took place on the King's Highway. The mounted robber declined as a consequence of developments in roads and policing. Prosecutions for the crime in London had all but finished by the 1830s.

A young Bonnie and Clyde pair, Lydia Paget, seventeen, and William Perry, fifteen, were indicted for assaulting Jane Preston on the King's Highway, on 4 October 1816, and for putting her in fear of her life. They also stole a shawl (value 1s) against her will. Preston was returning from Covent Garden Theatre with a female companion when she was accosted for no reason on Rathbone Place. Paget hit her in the face, kicked her then took her shawl. Paget then passed the shawl to William Perry. Fortunately, the watchmen was close by and was quickly arrested Paget who had stupidly come back to hurl abusive language at Jane Preston.

The offence might appear to be just another petty, but nasty, robbery committed late at night. However, it had been committed on the King's Highway and was deemed to be highway robbery, which carried the death sentence. Subsequently, the young pair were sentenced to death.

Extortion in a Public Toilet

Henry May was very proud to be the head waiter at the Scotch Stores on the corner of Burlington Mews, Regent Street. As he was walking home from work in the early hours of the morning of 18 September 1850 he called in to see a friend who lived at Charing Cross. On route he stopped at a urinal, one 'where there are partitions', on Regent Street. It turned out to be a case of wrong place, wrong time. A man came from behind May,

grabbed his shirt flap and said, 'if you don't give me a sovereign, I will charge you with an indecent assault.' May reacted swiftly by hitting the man in the mouth. As the man got up he snatched May's watch but May hit him a second time and called the police, whilst continuing to brawl in the rather undignified surroundings.

His attacker, John McDonnell, who was also the worse for wear with drink, broke free and, as he went into the street, he saw a policeman and immediately reported May for 'annoying' him. May offered his side of the story and both accompanied the policeman to the station.

McDonnell persisted with his account adding that May had also hit him, which was true. Now May was being accused of harassment, extortion, causing an annoyance and violent attack. Fortunately for Henry May, McDonnell had a similar charge brought against him two years previously. The court found McDonnell guilty and sentenced him to transportation for life. However, as we shall see, McDonnell had to wait two years before his punishment was carried out.

Industrialisation and urbanization between 1780 and 1850 saw a seemingly inexorable increase both of crime and of the prison population. In 1820, about 13,700 people were committed to trial for serious offences; by 1840 the figure had increased to 27,200. The number of prisoners almost doubled between 1820 and 1840. The system of punishments available seemed incapable of making a significant impact on these figures and this provoked anguished debates over crime and penal policy, particularly transportation. Time was running out for the whole concept of transportation. The settlers in Australia were asserting themselves and making it quite clear that they would not employ British convicts on public works unless Britain paid for them — which she was not prepared to do. The last straw for transportation was the discovery of gold in New South Wales and in Victoria in 1851.

Britain decided to send its convicts to Western Australia instead of New South Wales, Van Diemen's Land (Tasmania from 1856) or Norfolk Island. In 1850, the first 75 convicts arrived from England aboard the *Scindian*. Between 1850 and 1868, around 9,720 British convicts were sent directly to the Swan River Colony in 43 ships. In effect the system of transportation was coming to an end as Britain built larger, modern prisons at home. However, those that were sent to Western Australia were among some of the most hardened criminals convicted for serious crimes.

Convicts generally were well documented and, with the growth of interest in genealogy, we are learning more and more about convicts from their descendents.

John McDonnell had to wait until November 1852 before he sailed. When he did he went on the four-year-old, 601-ton ship *Dudbrook*, built in Dundee, which sailed from Plymouth. Voyages to Australia had shortened over the years and were even shorter now they went to the west coast. Seventy-seven days later, on 7 February 1853, the ship arrived in Fremantle, with its 238 convicts and 103 passengers.

McDonnell, forty-two, was described as being formerly a cook, five feet and eight inches tall, brown hair, blue eyes and having four children. His complexion was 'fresh', his

build 'slight' and he had scars on his forehead and back. He was in a new country serving a life sentence for blackmail and extortion.

Convicts were given a Ticket of Leave, which was a document granting them freedom to work and live within a given district of the colony before their sentence expired or they were pardoned. Such convicts could hire themselves out or be self-employed. They could also acquire property but they had to attend church. Tickets of Leave depend on the sentence they were given. McDonnell had been given a life sentence but he received his Ticket of Leave in July 1856. His Ticket of Leave date was set for 11 July 1856. What became of him? As with so many more convicts, his records may be waiting for some ancestor to discover.

Second Time Unlucky

Dennis Corbett came before the Central Criminal Court at the age of sixteen in November 1839. He, and eleven-year-old William Paine, stole six combs from Stephen Cooper, who kept a toyshop in Crawford Street, Marylebone. A police sergeant saw the two young rogues whilst they were pushing open the door to the shop. Corbett tried to put the blame on the younger Paine, saying that he had asked him to go in the shop with him. For their petty crime they received a whipping and were confined for nine days.

Corbett, who lived at Bryanston Square, Marylebone, clearly did not learn from that punishment and found himself before the same court only two months later. This time he was with a different boy, William Alexander, aged thirteen. On New Year's Eve, they had broken into the house of James Ross in St James' Street (off Oxford Street) and stolen two waistcoats. Corbett was either unlucky or incompetent when it came to breaking and entering, because he was seen yet again. This time, a Joseph Leathart was talking to a policeman when he spotted the boys shunning up a doorway. The policeman grabbed Corbett and saw something sticking out of his coat. When asked what it was Corbett replied, 'nothing'. In court, Corbett said that two men had asked them to pawn the waistcoats, which they were doing when the policeman arrested them.

This time he was not so lucky and both boys were transported for seven years each.

Thousands of young criminals like Corbett and Alexander went through the courts in the nineteenth century, to be sentenced to varying forms of confinement and punishment. Large numbers were placed on the hulk *Euryalus*, specially designed to accommodate children, during the 1820s and 1830s. Similarly large numbers of young offenders, including many from the *Euryalus*, were also transported to New South Wales. Boys sentenced to transportation were predominantly re-offenders, like Corbett, with two, four and sometimes eight or nine previous convictions, mainly for petty theft. In 1834, convict boys were sent to a purpose-built British institution for convicted male juveniles at Point Puer on Van Diemen's Land, where it operated until 1849. Some 13,000 boys

were transported there before 1850. Puer Point was the only juvenile penal station outside Britain in the British Empire. It sought, in the words of Governor Arthur, to rehabilitate 'little depraved felons'.

Home Office criminal records for Middlesex, for example, reveal that over ninety per cent of juveniles transported between 1791 and 1849 were male.

The Juvenile Offenders Act of 1847 made it possible for offenders under the age of fourteen (shortly afterwards raised to sixteen) to be summarily tried before two magistrates; this made the process of trial quicker and removed it from the exposure of the higher courts.

WHAT TWENTY-SIX SPOONS?

William Stone, aged twenty, was caught red-handed stealing goods but still protested his innocence. He had gone into the Gloucester Hotel in Piccadilly on 30 December 1850 and helped himself to twenty-six silver spoons from the coffee room. As he was creeping out the waiter caught sight of his shadow on the wall and immediately grabbed him by the collar. Stone dropped the spoons with a great clatter on the floor. When he was asked what he thought he was doing he answered, surrounded by twenty-six spoons, that he had nothing that belonged to the hotel. Well, technically he hadn't as they were all lying on the carpet. Stone was transported for seven years.

WEAK EXCUSE (2)

William Hack, twenty-four, had quite a haul after he had broken into the house of Theophilus Murcott on Oxford Street, 8 May 1850. Murcott's brother went to the shop at nine o'clock at night, lit a candle and found Hack crouching under the counter. Once again, we have a classic excuse. When asked what he was doing under the counter holding a bag of stolen goods a crowbar, skeleton keys and some matches Hack, replied that he was let in by someone who told him to carry out the bundle that was on the counter. The bundle contained eight guns and fifteen penknives.

Hack, an upholsterer, was transported for seven years and sailed on the *Pyrenees*, which left Torbay on 2 February 1853 bound for the Swan River Colony. After eighty-seven days, the ship landed in Fremantle with 97 passengers and 293 convicts. It is likely that on this ship Hack met the infamous Joseph Bolitho Johns, aka 'Moondyne Joe'. After arriving in Australia, Moondyne spent nearly fifty years in and out of Fremantle Prison, and he became something of a legend in Australian history.

VIOLENT ATTACK IN ROSE STREET

Thomas Miller (*c.* 1800-54) was a supplier of art materials by appointment to Her Majesty the Queen. On 2 August 1850, it was his misfortune to encounter Henry Denham, thirty-three, an illiterate slater, on a dark night. Miller was returning home around midnight when he had reached Rose Street off St Martin's Lane. The next thing he knew his arms were pinned from behind and he felt as though he was being strangled. After suffering a broken tooth and a fractured chin he managed to give chase before meeting a policeman and reporting what had happened.

Two months passed before Miller, by pure chance, caught sight of Denham. He wasted no time in telling the police, who then arrested Denham. He was transported for twenty years but did not sail until June 1863, so he was almost eligible for his Ticket of Leave. Denham's release date was set as 25 October 1870 but he died long before that in 1865.

FORGER AND CONMAN

Twenty years earlier, James Edward Green, alias James Wentworth, might have suffered the death sentence for the crime of forgery. In August 1849, Green applied to take a house on Savile Row from surgeon Henry Reynolds. Green said that he had returned from Egypt where he had been working as a surveyor to the Indian Railroad although he had conveniently lost the survey in transit. He also added that his father was Godfrey Wentworth, who was very well known.

Satisfied that he seemed a respectable fellow, Reynolds let him have the house. Green gave Reynolds two promissory notes because he said he was short of money, in consequence of having paid his sister's milliner's bill and his sister having gone to Ireland with the Queen. This information should have sent out immediate warning signs. Reynolds started to make enquiries about the 'well-known' Wentworth family and, as it turned out, they were well known but Green had nothing to do with them.

In court Green was exposed for the fraud that he was. He was transported for fifteen years for feloniously forging and uttering a promissory note for 60s, with intent to defraud Henry Reynolds. Thirty-four-year-old Green, who was married with six children, sailed on the *William Jardine* and arrived in Western Australia in August 1852. He never did see his day of freedom, as he died seven years later from consumption.

PICKING POCKETS AT THE PANTHEON

The Pantheon, on the south side of Oxford Street, opened in 1772 and was a well-known place of entertainment. Built as a set of winter assembly rooms, it was later, briefly,

The popular Pantheon, Oxford Street.

The interior of the Pantheon. Painting probably by William Hodges.

converted into a theatre. It served a number of roles throughout its history, including a theatre for concerts and masquerades, a bazaar and, in the 1860s, the offices of Gilbey's, wine merchants, until it was demolished in 1937.

Attracting crowds as it did, it also, inevitably, attracted criminals looking for rich pickings. Richard Crough, thirty, saw his opportunity in February 1802 when he mingled outside the door of the *Pantheon* late one night as people gathered to see the masquerade. Isaac Carcass was also standing there and fell victim to Crough's pick-pocketing skills. However, his skills clearly let him down that evening, as a number of people saw what he was up to; within seconds, a constable, who happened to be going to the *Pantheon* that night, grabbed hold of him as he tried to hide behind a Hackney Coach. Crough did not give up without a fight and it took another officer to help out.

When they searched him they found a pocketbook, handkerchief, four studs and four pawnbroker's duplicates — all the property of Isaac Carcass. Did Crough offer any excuse? Of course he did. He was only standing outside when somebody grabbed him and accused him of being a pickpocket. How did he account for the stolen goods? Those were brought in afterwards and he had nothing to do with them — they were planted. He was given seven years' transportation.

CHAPTER 20
Treason

THE CATO STREET CONSPIRACY

Cato Street is a rather quiet road tucked away just east of Edgware Road and would hardly be taken as the scene of one of the most potentially significant political events of the nineteenth century. The years following the Napoleonic years, those after 1815, were particularly severe and England was suffering from great social, economic and political upheavals. Inflation, food shortages and new patterns of factory employment led to distress and discontentment, which resulted in a series of disturbances in different parts of the country. In 1820, a group of radicals decided to take action against the government by plotting to behead every member of the Cabinet.

These radicals called themselves the Society of Spencean Philanthropists after the radical Thomas Spence and pledged that they would keep his ideas alive after he had died, which was in 1814. Spence was an advocate of revolution and the common ownership of land. His supporters, who had been involved in a number of events, such as the Spa Fields riots in 1816, met in public houses, one of which was the Horse and Groom in Marylebone, to discuss the best way of achieving their ideas of an equal society. One of the conspirators, William Davidson, was born in Jamaica in 1781 and had become radicalised as a result of the events after 1815, particularly the Peterloo Massacre of 1819. He joined the Marylebone Union Reading Society where he met another conspirator, John Harrison. Shortly afterwards Davidson also became a Spencean and, as a result of joining the organisation, he met Arthur Thistlewood, who had already been labelled a 'dangerous character' by the police.

The activities of the group had already become a cause for concern to the government, who decided to plant spies among the radicals. In 1817, John Stafford, Chief Clerk at Bow Street, who recruited Home Office spies, asked a police officer, George Ruthven, to join the Spenceans. Ruthven eventually discovered that the group were planning an armed rising.

The Peterloo Massacre, which took place in Manchester, had caused great anger when the cavalry charged into a peaceful crowd killing 11 people and injuring over 400. Thistlewood declared this to be an act of treason and resolved that the 'instigators should atone for the souls of murdered innocents.' When the Spenceans heard that several members of the Government were to have dinner in Grosvenor Square, this provided them with not only the opportunity to avenge Peterloo by killing the entire cabinet but also to incite an armed uprising. The plan would involve an armed attack on the Cabinet, with

the use of hand grenades and guns. Once captured every member of the Cabinet would have their heads removed, and those of Castlereagh and Sidmouth would be displayed on pikes on Westminster Bridge.

Thistlewood attempted to recruit as many people as possible but only twenty-seven people agreed to participate, including George Edwards, William Davidson, James Ings, Richard Tidd, John Brunt, John Harrison, Richard Bradburn, James Wilson, Charles Copper, John Strange, Robert Adams and John Monument.

Harrison announced that he knew of a small, two-story building in Cato Street that was available for rent. The building consisted of a ground floor and a hayloft. Cato Street was conveniently located to Grovesnor Square and was considered to be a good base from which to carry out the plot.

George Edwards was a government spy who told Stafford of the plan. The authorities quickly responded by dispatching men from the Second Battalion of the Coldstream Guards as well as police officers from Bow Street to arrest the Cato Street Conspirators. George Ruthven was sent to the Horse and Groom, which overlooked the stable in Cato Street. On 23 February 1820, Ruthven took up his position at two o'clock in the afternoon. At seven-thirty in the evening twelve police officers joined him, but the Coldstream Guards had not yet arrived. This did not matter as it was felt there were enough men to carry out the arrests. George Ruthven led his men into the hayloft where the conspirators were meeting. A skirmish followed and Thistlewood stabbed one of the officers, who died shortly afterwards. Although Thistlewood, Brunt, Adams and Harrison escaped they were soon arrested.

Eleven men were charged with being involved in the Cato Street Conspiracy, and, on 28 April 1820, Thistlewood, Davidson, Ings, Tidd and Brunt were found guilty of high treason and sentenced to execution at Newgate. Harrison, James Wilson, Richard Bradburn, John Strange and Charles Copper were transported for life. Cato Street would be forever associated with a major attempt at insurrection. *The Sunday Observer* of 3 March 1820 stated that, 'The premises in Cato Street, which will be ever memorable for the events of which they were the scene, was visited by several thousand persons. Among whom were many individuals of the highest rank.'

The execution of the conspirators was the last public decapitation of condemned persons in England. Additional barricades were erected in anticipation of the large crowds of spectators and an additional platform was added at the back of Newgate's normal gallows. The new platform was covered in sawdust to absorb the blood and the men's coffins placed on it in readiness. At 8 o'clock, the drop fell and the traitors were suspended.

The Traveller, May 1820, recorded that:

The executioner, who trembled much, was a long time tying up the prisoners; while this operation was going on a dead silence prevailed among the crowd, but the moment the drop fell, the general feeling was manifested by deep sighs and groans. Ings and Brunt

were those only who manifested pain while hanging. The former writhed for some moments; but the latter for several minutes seemed, from the horrifying contortions of his countenance, to be suffering the most excruciating torture.

It took about five minutes for all visible signs of life to be extinguished, but they were left on the ropes for half an hour to ensure total death. The bodies of the men were then drawn back up onto the platform and placed on their coffins with the neck of each over a small block set at the end of each coffin in turn. The rope was removed and each head severed by a masked man using a surgical knife. In traditional style, the executioner showed each of the heads to the crowd proclaiming, 'This is the head of a traitor.'

CHAPTER 21
Violence

Violence is ugly and never more so than when perpetrated against children, especially from a parent. We hear of dreadful cases today and, tragically, such acts have been all too common.

Eight-year-old Mary Moore was one of the many unfortunate children subjected to violence by a parent. She lived with her mother, Ann Moore, on Molyneux Street, which runs parallel to the famous Cato Street, along with a male lodger called Addis and five other people. On 27 February 1841, poor Mary was doing no more than standing in her room, waiting to go to bed, when her mother, for no apparent reason, picked up the tongs and beat her daughter around the head. In her own words Mary told the court:

> I had not done any thing to her or been naughty at all, my mother was sober. Addis was not there at the time, this was after tea and dark, but we had a light in the room, she did not say any thing when she struck me, she hit me on the side of the head, it bled, and she put some salt on it, which she got from the cupboard.

The police confirmed that her head and body were in a terrible state.

Mary was used to violence from another member of the household. She said that Addis had beaten her when he was 'tipsy'. Mary declared that she never did anything to warrant the violence, saying 'I never tell stories ... I did not scream out ... my mother and Addis have never told me I was a naughty girl.' Witnesses testified to hearing the girl scream and the fact that she was regularly beaten.

Mary was taken to Marylebone Workhouse where a surgeon tended to wounds on her head, body and neck. He noted that she 'appeared to have been very ill used, one eye was closed'.

Her mother was found guilty of assault and sentenced to two years' confinement.

Zero Tolerance on Knife Crime

James Mayden, forty-nine, was the sort of man most people would not have wanted to cross. Unfortunately for George Green, he did cross him and paid for it with some serious injuries. In August 1828, Mayden and Green, who both lived near Grosvenor Place, got into an argument after Mayden had been provoking him with abusive comments.

The incident started when Mayden taunted Green, which then led to some pushing before Green, after taking this for too long, asked Mayden to come out and fight like a man. Mayden responded in the most violent way. He stabbed Green in the stomach and then struck him so hard in the eye with the knife his eye came out. Witnesses said the blow could be heard fifty yards away. Mayden's defence was that he had only intended to knock Green's hat off but missed and stabbed him in the eye by mistake, much to his regret.

Mayden's defence fell on deaf ears, and he was found guilty of intended grievous bodily harm, for which he received the death sentence.

CHAPTER 22
Violent Robbery

In *Policing the Crisis: Mugging, the State and Law and Order* (1978) the rise of the 'mugging phenomena' was examined. It was taken to be a new form of crime in the 1970s. The authors argued that public concern had been fuelled and created by the media, which in turn prompted a response from the police in 'cracking down' on this type of activity. The authors also contended that supposedly deviant groups are periodically singled out and placed at the centre of a series of moral panics that allow the state to demonstrate that it has the people's consent to maintain the status quo through an increase in 'law and order'. Throughout history examples can be found of a growing concern with crime that appears to be getting out of hand. The 1970s were not unique although the names we give to forms of crime may change. The term 'mugging' was not used in, for example, the nineteenth century but violent attacks on individuals were just as rife then.

The Violent Thief who was Later Recognised

In May 1814, Francis Sturgess was indicted for assaulting John Scotland and 'putting him in fear, and taking from his person and against his will, 5s. 6d.'

Scotland, who lived on King Street, Seven Dials, had reached Lisle Street (between Piccadilly Circus and Leicester Square) on his way home one evening after visiting a friend who lived at St James'. Scotland was then confronted with that awful moment of terror caused by a group of threatening people. In this case it was three men and a woman. They grabbed Scotland by the shoulder and then accused him of promising the woman money and also of ill-treating her. Scotland had never seen any of them before that night. They then started insulting him, and he was clearly very frightened. He told him them he had some silver and offered them 3*s*, but this was obviously not enough for the thugs, so he gave them whatever money he had on him. After some pushing and threats they eventually let Scotland go. He was fortunate, as the situation could have been much worse.

However, that was not quite the end of the matter. Scotland saw one of the men a few days later under the piazza in Covent Garden and approached him, asking if he remembered what had happened that evening in Lisle Street. The man, feeling less brave without his partners in crime, walked off and then started to run. Scotland chased him into a public house and, with the aid of another man, managed to arrest him.

The popular piazza of Covent Garden.

In court, the accused, Francis Sturgess, denied everything saying he was acting in good faith on behalf of the woman. For his one evening of robbery, forty-year-old Sturgess was given the death sentence.

A FEMALE MUGGER

Forty-eight-year-old Martha Davis was charged with assaulting and robbing fifteen-year-old Charles Titswell, a foot-boy, while on an errand for his master. She took a hat, valued at 10s; a silver band, valued at 8s; and a half-crown piece. The boy was on his way to Covent Garden at about seven o'clock in the evening but took a wrong turn and went along Dyott Street (off the present New Oxford Street). He was suddenly snatched by his arm and dragged down a passage and into a room.

The woman then searched his pockets, knocked him down with several blows of her hand and threatened to murder him. After she stole half a crown from him he was then dumped back into the passage. If the boy thought that was the end of his ordeal he was mistaken. The woman came after him once again. It was only the intervention of a mob and a watchman that saved him. The watchman then pursued the woman and arrested her.

The Newgate Calendar was less sympathetic in its reporting of the crime. It stated that:

In London a set of daring prostitutes of the lowest description all night long prowled about the streets in order to prey upon unguarded youth. Even in the light of day, as in the present case, they were often daring enough to seize any victim who might accidentally pass their door, drag him into their den of misery, then ill-treat and plunder him. Circumstances of this nature have come to our knowledge, where apprentices and servant-lads have been inveigled by them, stripped, forcibly detained till midnight, and then, almost naked, turned into the street.

Martha Davis fell into this category of dangerous predator. The boy survived with some bruises, a big scare and the loss of his master's money. The death sentence imposed on Martha Davis clearly reflected the attitude of the authorities to this class of person.

'COME INTO MY PARLOUR'

Many correspondents to *The Times* were keen to draw attention to any variety of misdemeanors that they felt were a matter of public concern. One such correspondent on 11 December 1849 warned the 'timid' to be on their guard against a 'gang of wretches who infest the passage leading from St Martin's church to Bear and Orange streets,

Watch House in Marylebone Lane. Watchmen getting ready for work. Rowlandson and Pugin c. 1810.

Leicester-square' carrying out the 'horrid system of extortion at dusk'. The approach of these gangs was for a smartly-dressed, well-looking boy to ask someone the time and then keep them in conversation. A few moments later a man would approach asking what the man was doing with his son, which was then a cue for the boy to start crying and accuse the man of proposing some grossly immoral purpose. Of course, the only way the man could save his reputation was to give the boy some money.

Similar extortion activities had been happening around this area much earlier. On 13 November 1819, Robert Arnott was walking along the Strand near Charing Cross around midnight when a woman he had never seen before charmed him against his better judgment into going into a nearby parlour. Once inside, the woman, Hannah Barker, asked him for some money to buy a drink. When he refused, Arnott must have then wondered what he had let himself in for. Barker started screaming 'murder'. Within minutes the supporting gang came storming into the room and one of them hit Arnott in the mouth. Arnott had walked straight into a trap. As he was on the floor two men continued hitting him, while a woman went through his pockets and took what money he had.

A nearby watchman, who was patrolling the street, heard Arnott's cries for assistance. He forced open the door of the house and frightened the gang, who took flight up some stairs. With the help of two other watchmen, who had heard the commotion, the gang was eventually caught. Barker sobbed uncontrollably. The gang, James Miller, thirty-five; William Howard, nineteen; Mary Campbell, twenty-three; Elizabeth Smith twenty-four; and Hanah Barker, twenty-two, were all given the death sentence for putting Robert Arnott 'in fear' and taking from him and against his will, two handkerchiefs, and 18s in money.

'THE DUFFERS'

Organised gangs have a long history in the West End. One particular gang, known as the 'Duffers', prompted a concerned citizen to write to *The Times*, on 14 December 1843, expressing concern with the activities of these villains. The gang had been known for over twenty years, with at least one of their members, 'a wooden-legged man', transported for acts of violence.

The writer reported how the son of a friend had been walking near Charing Cross when a well-dressed man, asking if he wanted to buy some cigars, accosted him. The young man foolishly went with him to a pub in Bedfordbury, between Leicester Square and Covent Garden. Laying in wait were several others of the gang, who pushed him to the ground and stole all his money.

The gang got away with it, much to the anger of the correspondent, who insisted that the 'police should put down these nuisances by apprehending all such persons, and punishing them as rogues and vagabonds ... these fellows have become exceedingly numerous, and may be found in most of the leading thoroughfares.'

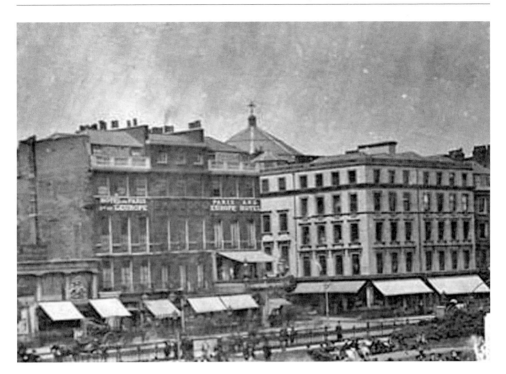

Leicester Square in 1880.

Leicester Square today.

CHAPTER 23
Workhouse

The parish workhouse was the visible institutional symbol of poverty. According to the 1861 census there were 65,000 people recorded as special inmates (paupers, patients, lunatics, prisoners, etc.) in London institutions. The West End had a number of workhouses including St Martin in the Fields, St George's in Hanover Square, St Giles', St James' and Marylebone. Whilst the many poor souls in these places were concerned mainly with survival there was also a great deal of petty stealing. These crimes often paled against the dreadful conditions that many were subjected to by the Guardians of the Poor.

Many ex-prisoners were in poor states of health and some resorted to the workhouse on their release. In a report in the *Builder*, October 1868, it was noted that there was a great increase in the proportion of 'convicts who are of a weakly and diseased constitution'.

The original St James' workhouse was erected in 1725-7 and was located between Poland Street and Marshall Street in Soho. During the eighteenth century, the workhouse was reported to be in a 'very nasty condition, the stench hardly supportable, poor creatures almost naked and the living go to bed to the dead.' The greatest danger was the 'Scorbutick Distemper' (scurvy), which few escaped. By 1814, the workhouse buildings had become 'very dilapidated and dangerous' (especially the infirmary) as well as severely overcrowded, with many sleeping three in a bed. Little surprise that in the following year a contagious fever broke out among the inmates. In 1817, another temporary infirmary was opened in nearby Broad Street.

A new dormitory block was erected in the workhouse in 1821, with some of the new buildings sited upon parts of the workhouse yard, which covered a former burial ground for plague victims. The unearthed human remains were deposited in a new brick vault.

The workhouse was not without its own criminal activity despite there being little of real value in such places. In October 1818, fifty-six-year-old pauper Cuthbert Ramshaw stole a piece of woolen cloth worth 5s, the property of the governors and directors of the poor of the parish of St James. For such an ungrateful show of behaviour towards his masters Ramshaw was whipped and given three months' confinement.

Another thief, seventeen-year-old John Dunn, who had spent his whole life as a pauper in the workhouse, stole some items in 1818. The items consisted of one coat, a pair of trousers and a waistcoat belonging to James Horwood, master of the workhouse. Dunn, who was probably conditioned to the harshness of life in the institution, also received a whipping.

St Marylebone parish workhouse began operation in 1730, and in the following year Edward Harley, the Earl of Oxford, bequeathed land to the south of Paddington Street for

use as a burial ground and for the building of almshouses and workhouses. In 1752, a new workhouse, with about forty inmates, came into use. The new building proved inadequate to deal with a growing population, overcrowding and an infestation of rats, so building on another workhouse began and was completed during the mid-1770s. This accommodated nearly 300 inmates, with extensions being added over the years. However, by the 1840s the demand for places in the workhouse exceeded 2,000 and, with such high numbers, there were pressures to economise. In 1856, allegations were made against workhouse staff for beating several young female inmates.

The inmates of the workhouse were employed in manufacturing sacks, with money earned going towards their maintenance. In 1833, thirty-seven-year-old Robert Sutton was indicted for embezzlement. However, he was not an inmate but a clerk who dealt with cheques and this put him in a position whereby he could fiddle the books and siphon off money for the sacks into his pocket. For his little scam he too would now be institutionalized in a different regime. He was sentenced to seven years' transportation.

Other petty thefts in the workhouses of the West End included seventy-six year old pauper William Patterson who was confined for three months in 1820 for stealing a pound weight of paper from the Directors and Guardians of the Poor, of St Marylebone. Seventy-three-year-old pauper William Raynes who stole seven pounds of horsehair in 1832 was confined for seven days.

WORKHOUSES AND THE ANATOMY ACT OF 1832

Body snatching, as we saw earlier, was rife because the only corpses available for medical study were those of hanged murderers. However, the 1832 Anatomy Act made it an offence to rob graves and it was only legal to dissect the unclaimed bodies of people who had died in hospitals or workhouses. As if the stigma and fear of the workhouse was not bad enough, it was now made infinitely worse. Workhouses responded differently to the demands for the bodies of their poor. In the 1830s, Marylebone had consistently failed to provide corpses at the expected rate; compared with St Giles' workhouse that delivered 709 of its 'unclaimed' poor for dissection, Marylebone gave up only 58. The system of delivering corpses of the poor also led to corruption. At St Giles' parish in 1841 'considerable excitement' was caused when it was discovered that the workhouse mortuary keeper, who had been bribed, had decapitated a smallpox victim's body (Ruth Richardson, *Death, Dissection, and the Destitute*, Penguin 1989).

The West End has long been a popular, diverse and exciting area of London and the diversity of the crimes reflect this. As we have seen, the period 1800-1850 witnessed crimes ranging from brutal murder to the pettiest misdemeanors. Later periods have had their share of scandals, deaths, violence and theft and from the twentieth century the rise of organized criminal gangs became a particular feature. The West End has continued to attract large numbers of visitors, whilst also maintaining its reputation as the crime capital of London.

Also available from AMBERLEY

JONATHAN WILD
LONDON'S FIRST ORGANISED CRIME LORD
JOHN VAN DER KISTE

The first book to explore, in depth, the myths and legends surrounding
this notorious criminal.

Price: £12.99
ISBN: 978 1 84868 2191
Size: 235 x 165mm

Available at all good book shops and online
www.amberleybooks.com